APERTURE

"Explorations," the first issue of *Aperture*'s fortieth-anniversary year, celebrates tradition by breaking it. In a departure from our usual thematic approach, this issue features ten distinctly individualistic photographic portfolios.

"Explorations" was a collaborative effort. In an attempt to produce a more global view of the constantly evolving photographic medium, *Aperture* put together a distinguished international group of advisors and asked each to give us the names of three photographers whose work they felt was superb though not yet widely known— ultimately a somewhat subjective guide. Out of these selections, we chose the artists featured here.

The confluence of imagery and visions represented in this volume journeys from the sublime to the cleverly ridiculous: from ghostly landscapes to stirring investigative reportage, from what seems like a fishy play on Arcimboldo to humorously agonizing inversions of tableaux vivants. *Aperture* is proud to present the work of these artists, and grateful to our advisors for their input and for ensuring the diversity and vivacity of our explorations.

<div align="right">THE EDITORS</div>

Advisors: Kinshasha Holman Conwill, *Executive Director, The Studio Museum in Harlem, New York.* Christian Caujolle, *Director, Agence VU, Paris.* Amada Cruz, *Associate Curator, Hirshhorn Museum and Sculpture Garden, Smithsonian Institution, Washington, D.C.* Joseph Fung, *M.F.A., Lecturer, Swire School of Design, Hong Kong.* Jonathan Green, *Director, California Museum of Photography, Riverside.* Sue Grayson, *Director, The Photographers' Gallery, London.* Willis Hartshorn, *Deputy Director for Programs, International Center of Photography, New York.* Kohtaro Iizawa, *Editor-in-chief, déjà-vu, Tokyo.* Pedro Meyer, *Photographer, Mexico.* Dr. Sandra S. Phillips, *Curator of Photography, San Francisco Museum of Modern Art.* Ned Rifkin, *Director, High Museum of Art, Atlanta.* Paul Schimmel, *Chief Curator, Museum of Contemporary Art, Los Angeles.* Tom Southall, *Curator of Photographs, Amon Carter Museum, Fort Worth.* Trudy Wilner Stack, *Curator, The Center for Creative Photography, University of Arizona, Tucson.* David Levi Strauss, *Guest Editor, San Francisco Camerawork.* Tina Summerlin, *Director, The Robert Mapplethorpe Foundation, New York.* Anne Tucker, *Curator of Photography, The Museum of Fine Arts, Houston.* Colin Westerbeck, *Assistant Curator of Photography, The Art Institute of Chicago.* Eelco Wolf, *Boston.* Sylvia Wolf, *Assistant Curator of Photography, The Art Institute of Chicago.*

EXPLORATIONS:

TEN PORTFOLIOS

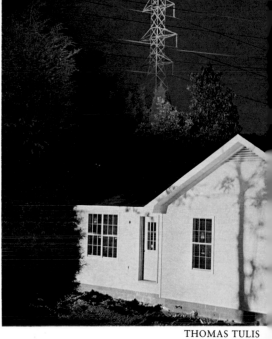

THOMAS TULIS

4
ROCKY SCHENCK

12
LU NAN

18
CHRISTIAN WALKER

26
MARY KOCOL

32
TEUN HOCKS

39
THOMAS TULIS

42
ANNE TURYN

48
ANNETTE MESSAGER

54
MICHIKO KON

62
DORE GARDNER

70
PEOPLE AND IDEAS

Review of lunar maps at Gagosian, by Richard B.
Woodward; "Photographing the Mind's Eye,"
by Clay Reid; Review of William J. Mitchell's
The Reconfigured Eye, by Michael Sand;
Review of Joel Sternfeld's
Campagna Romana, by David LaPalombara.

78
CONTRIBUTORS AND CREDITS

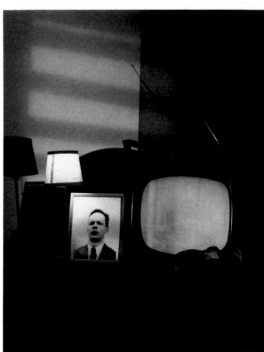

ANNE TURYN

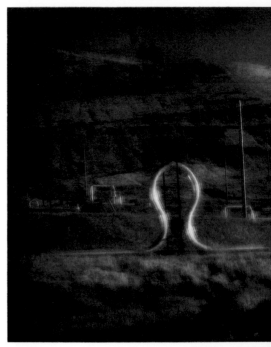

ROCKY SCHENCK

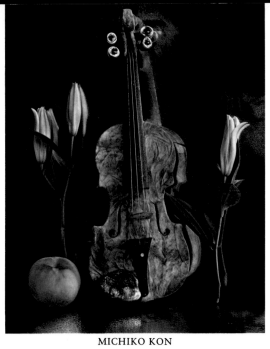

MICHIKO KON

CHRISTIAN WALKER

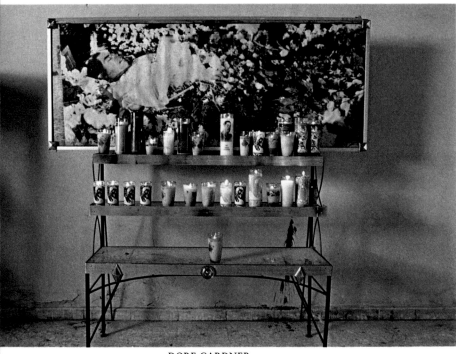

DORE GARDNER

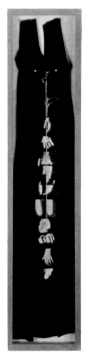

ANNETTE MESSAGER

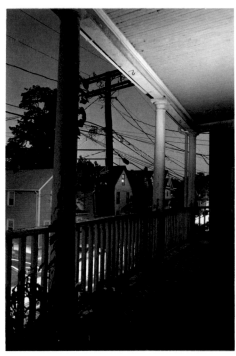

MARY KOCOL

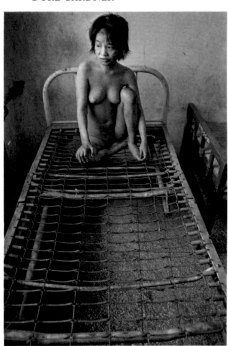

LU NAN

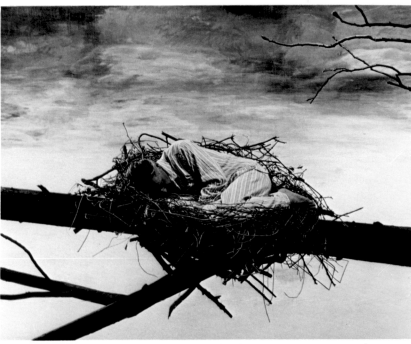

TEUN HOCKS

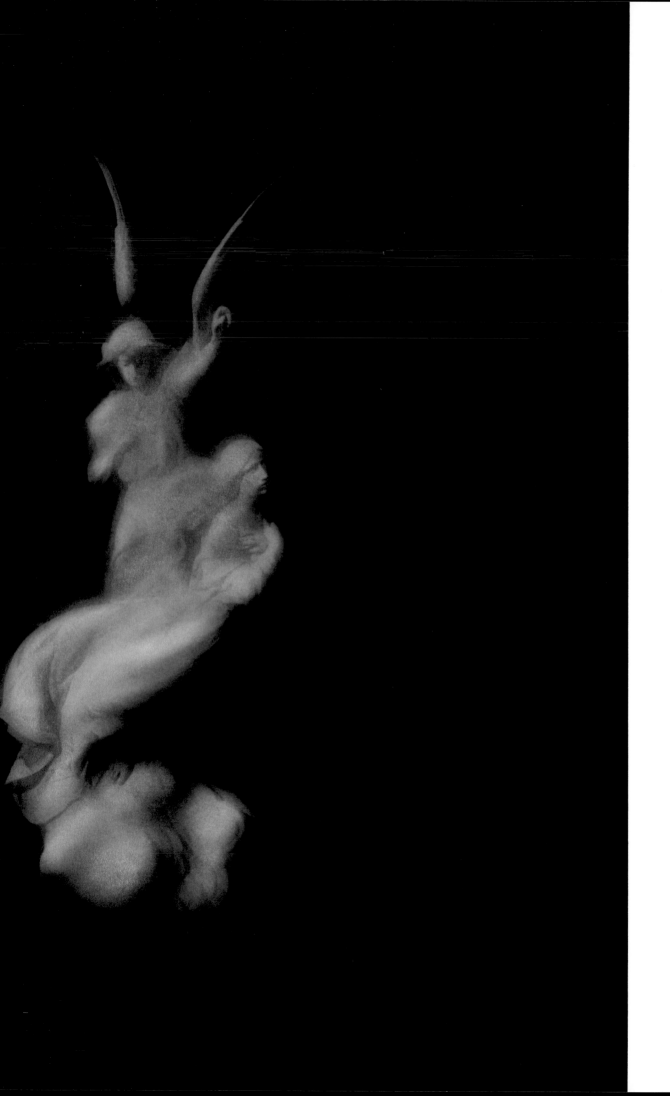

ROCKY SCHENCK

"It's like I'm floating in space, waiting to get to my final destination, whatever that is."

Aperture: Why do you choose to photograph landscapes?

Rocky Schenck: Well, it's almost like therapy for me. It gives me peace of mind. I love going away by myself, just disappearing and being left alone with my thoughts and my camera. I look at it as a journey to find things out about myself—and in the meantime, I take pictures.

A: You took these pictures in many parts of the world, yet they all have a similar quality—why?

RS: They could almost be manufactured landscapes, because of the way they've been manipulated. They're really landscapes from my imagination. I can manipulate them into almost whatever I want. They could have been taken anywhere. I just go by my instincts and keep working on the photographs until they have the right kind of emotional impact for me, and create the mood that I want.

A: Is the mood that you're after ever religious in nature?

RS: Well, sometimes, since my belief is that there are guiding angels watching over me—I can't speak for anybody else! I feel like they're friendly spirits. I do talk to them occasionally, but they don't talk back.

There's also a water influence. I tried to figure out why I'm fascinated with waterfalls and fountains and pools of water. One thing that comes to mind, which I might have completely created in my head or created with several therapists, is the fact that my parents had me baptized three times, which made me feel that I was never quite good enough—that it would take several baptisms to cleanse my soul.

A: When did you first start taking pictures?

RS: I'm a filmmaker also, and I started taking photographs on the sets of my experimental films in 1972 or '73. I made short super-8 films. I started making them in Dripping Springs, Texas, which is where I'm from.

A: Does the feeling you were trying to evoke in your films show up in your photography?

RS: Mostly, I think, in these landscapes. To me there's something dark and disturbing in a lot of the landscapes. Maybe it's my constant journey to figure out why I am the way I am. It's like I'm floating in space, waiting to get to my final destination, whatever that is.

A: Why do you photograph statues of angels?

RS: Well, I think it would be difficult to photograph a real angel. Maybe they're standing out there somewhere in that field of sunflowers.

Opposite: *Guiding Angel,* 1990
Right: *In Between,* 1990

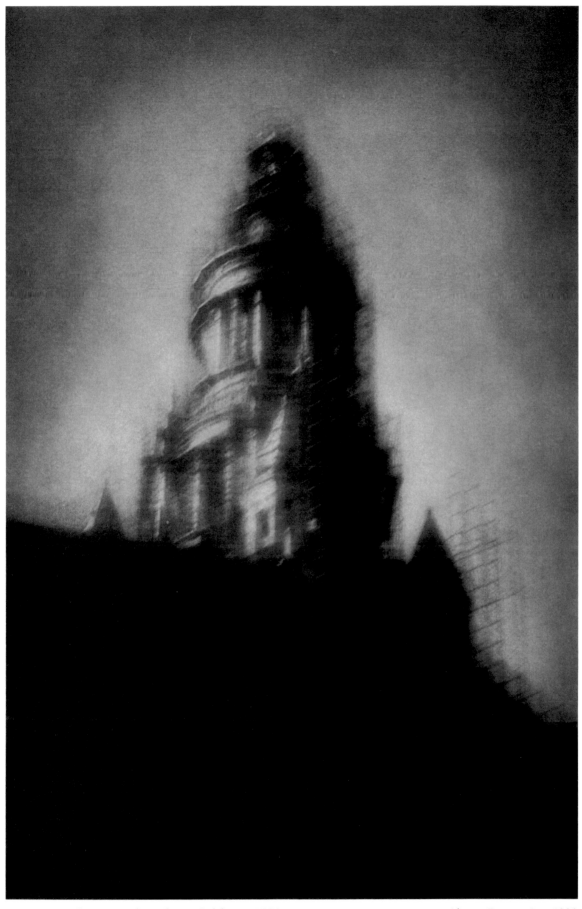

Opposite: *Highway to Independence, California*, 1990 Above: *Restoration*, 1990

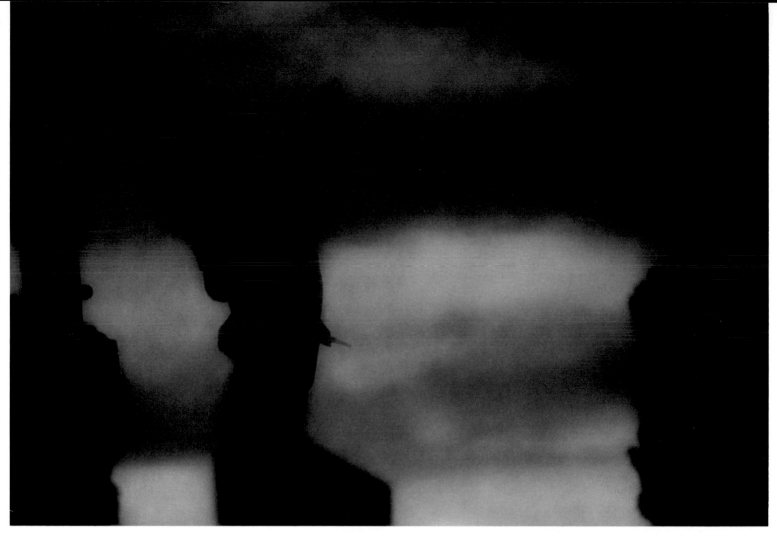

Above: *One Way*, 1990

Below: *Three Trees, Manresa*, 1990

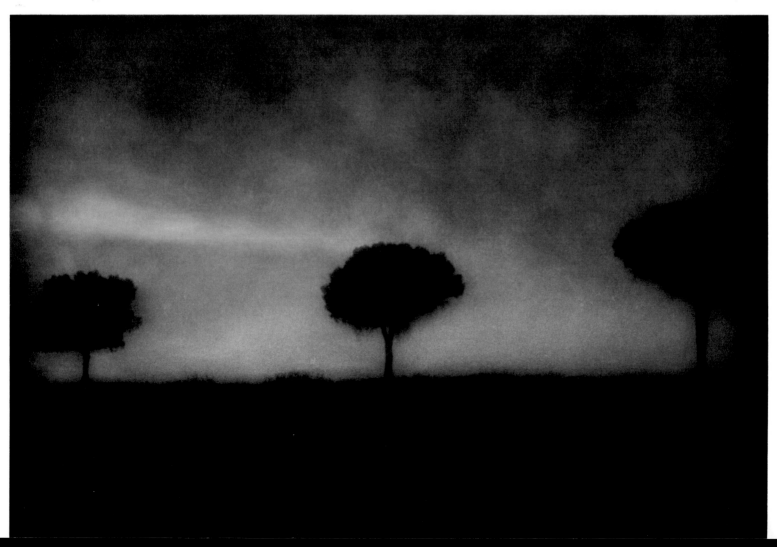

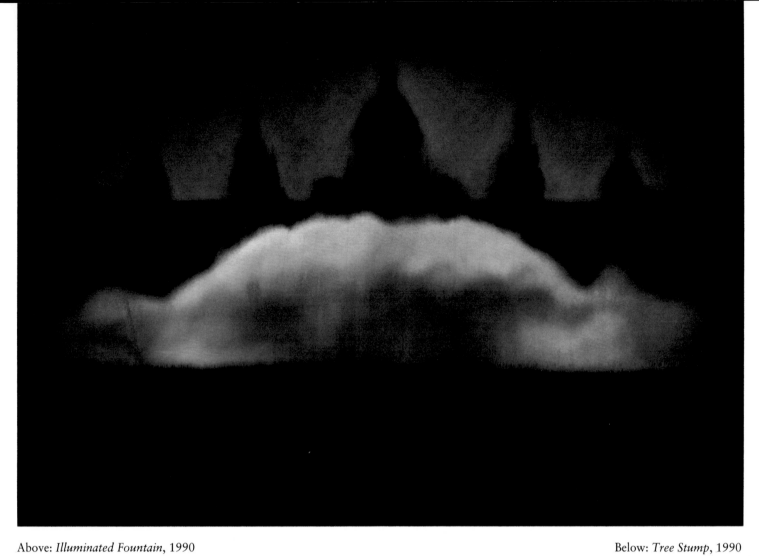

Above: *Illuminated Fountain*, 1990

Below: *Tree Stump*, 1990

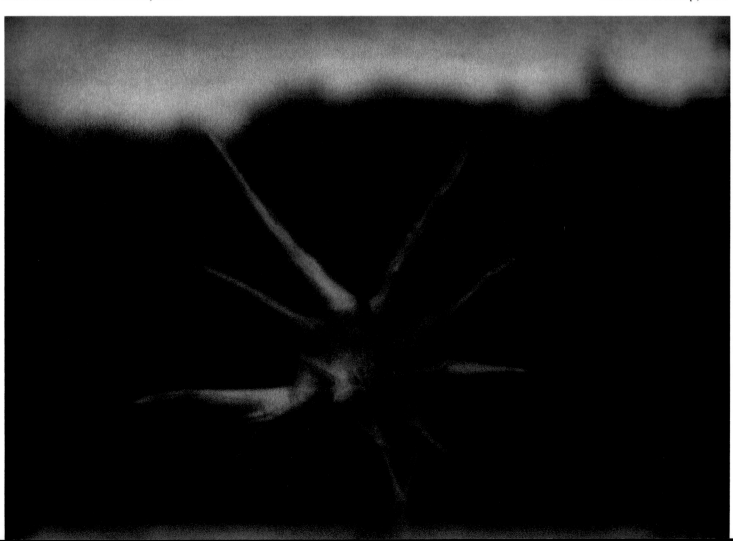

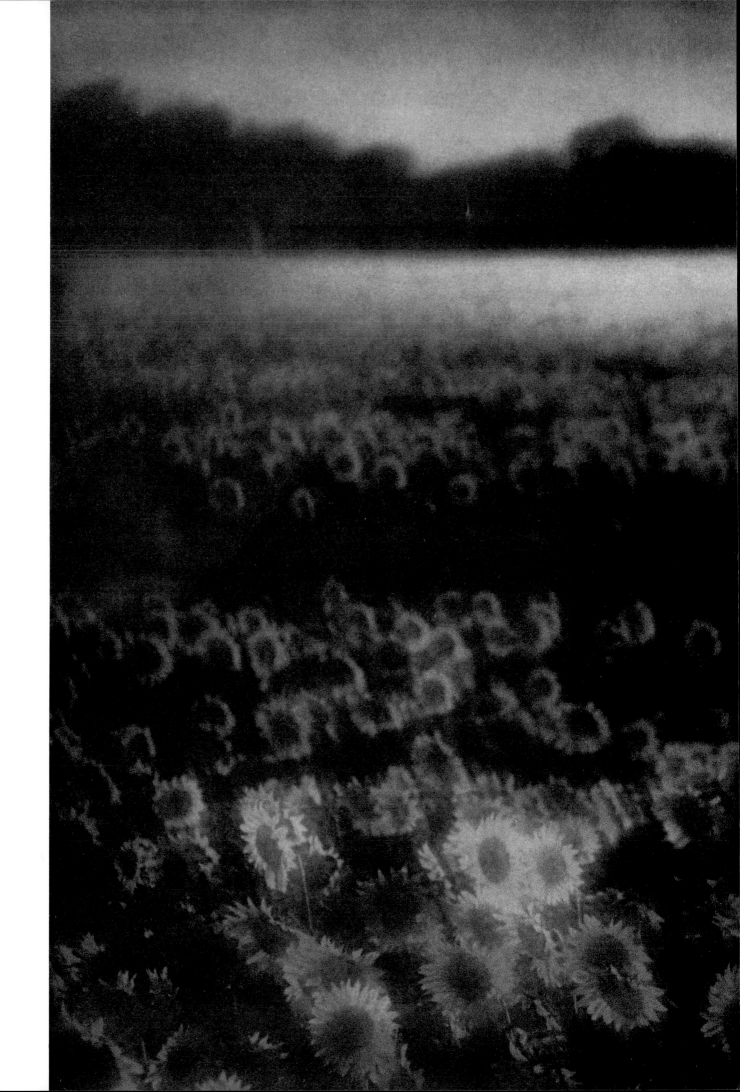

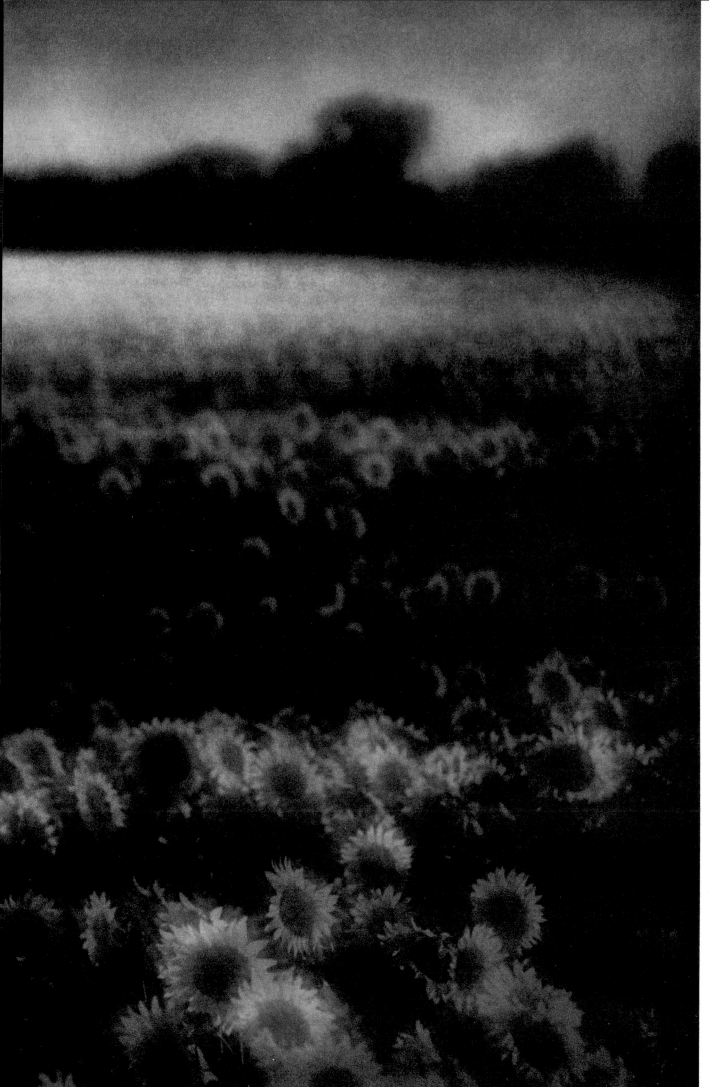

*Sunflowers
in Roses,
1990*

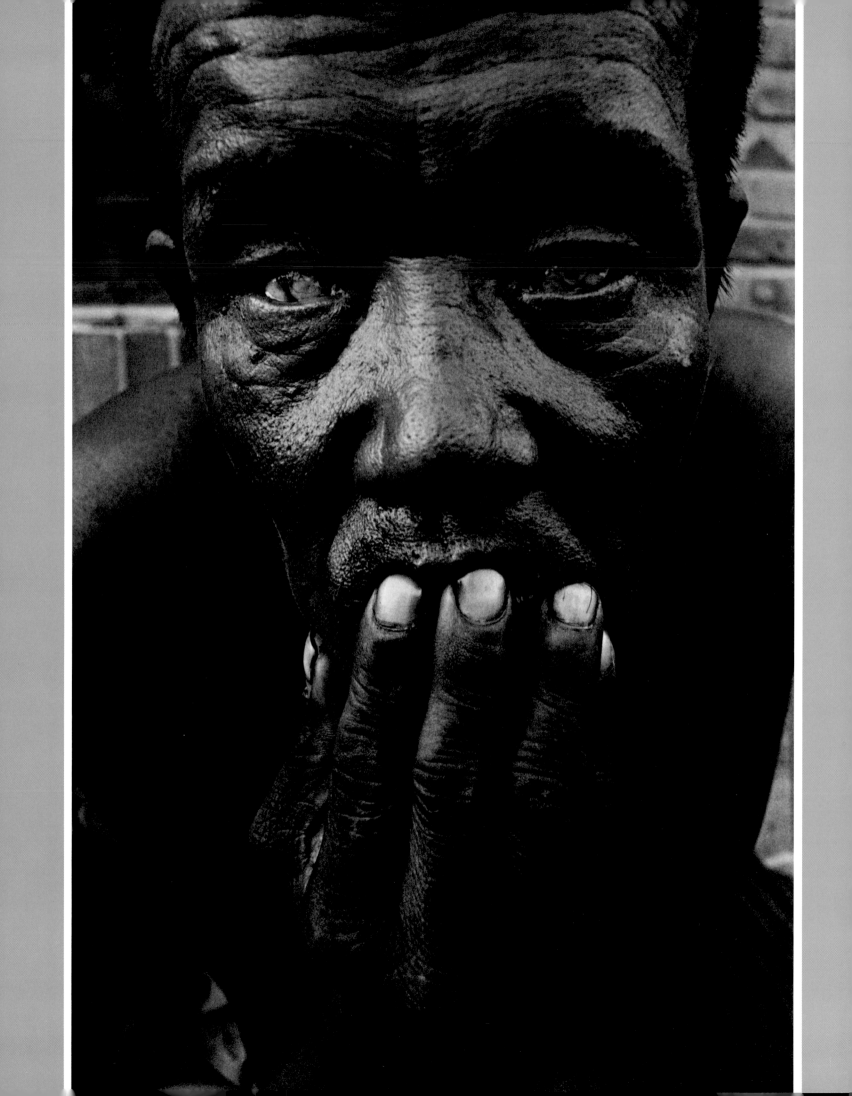

LU NAN

"I think the fact is that once you confront the people in these institutions, you'll sense that they are in paradise—only in the institutions will they be treated equally."

Aperture: Why did you choose photography as a medium of expression?

Lu Nan: I started taking photographs seriously in 1986, a year after I joined the *National Pictorial* magazine in Beijing as a darkroom worker. It's a kind of obsession that has drained all of my energy. I had, of course, other options, but I went back to photography. After all, that's all I can do well—if I can't make it work, I'm through. I do envy those who can write, but I find it impossible to express my ideas through writing, so I am stuck with photography.

A: Why do you photograph at mental institutions?

LN: That is a complex question, which I do not discuss often. To be frank, I did have some kind of social function in mind at the start of the project. Eventually, I became so attracted by what I encountered in these institutions that I forgot what I had intended to do in the first place. It was not long before I realized that I was actually trying to arouse a kind of sympathy, a kind of humanity. To photograph something like this calls for courage, courage to confront what seems alien to myself, no matter how horrifying. Some photographers don't want to face the truth, the things they are confronted with. They would rather try to distort the truth, in a way, with their cameras. One must have sympathy and integrity toward one's subject. I think the fact is that once you confront the people in these institutions, you'll sense that they are in paradise—only in the institutions will they be treated equally. I even dare to say that by looking at mental institutions and jails, one can identify the level of civilization of a country. Here, mental institutions seem convincing evidence of progress in China. I always believe that the attitude of a country toward these poor souls reflects a level of humanity.

Translated from Chinese by Joseph Fung.

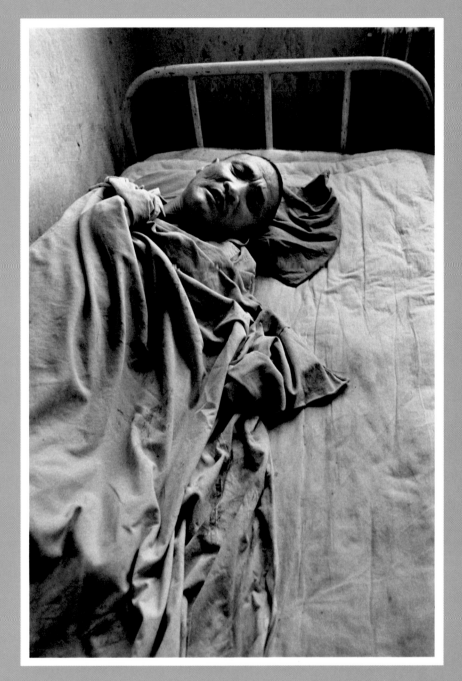

Opposite: Tienjin, China, 1989. Li Jia-lin, age forty-seven, mentally retarded and blind, had, at this time, been in the institution for over a year. Any time he sensed a person in front of him, he would murmur: "They bully people."

Above: Tienjin, China, 1989. Yanh Juan, age thirty-five, a "three no" patient (one who has no job, no family, and no financial income) was here for ten years suffering from tuberculosis. He didn't live through 1989.

The number of mentally and physically disabled patients in China ranks the highest in the world. There are more than ten million patients in China, approximately 1.26 percent of the population. According to recent statistics, the total number of beds available for mental patients is around one hundred thousand. Wards in these institutions are usually crammed with worn furniture and equipment from the 1950s.

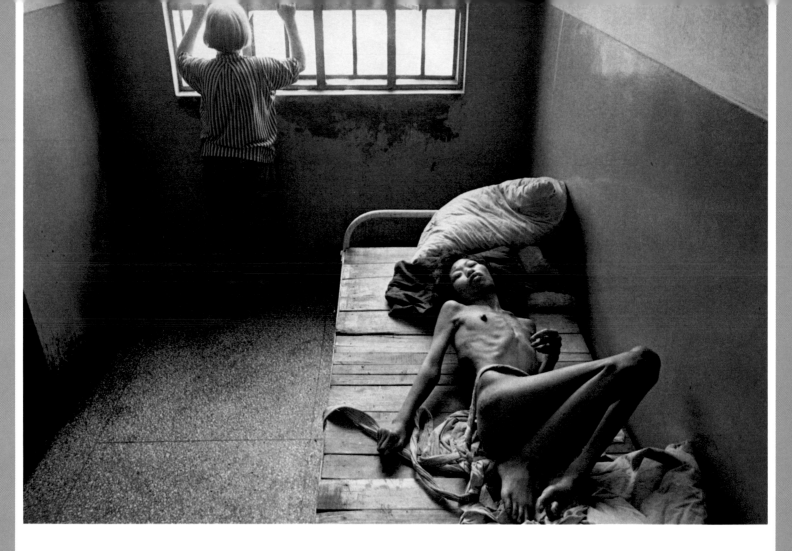

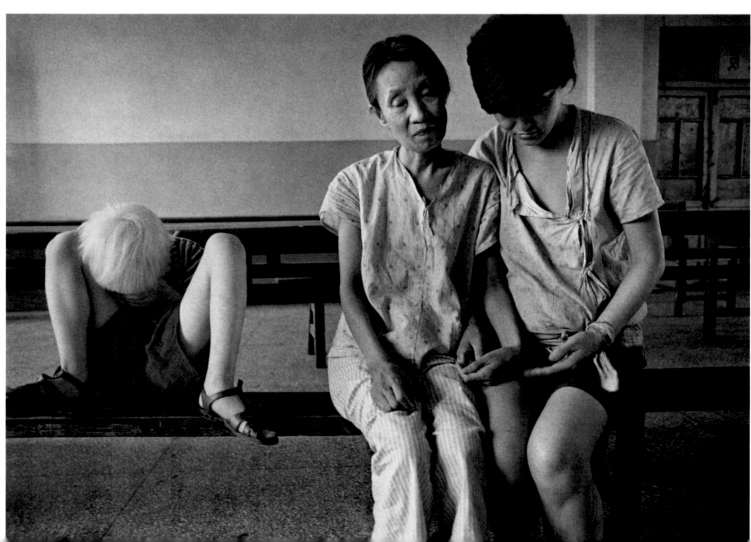

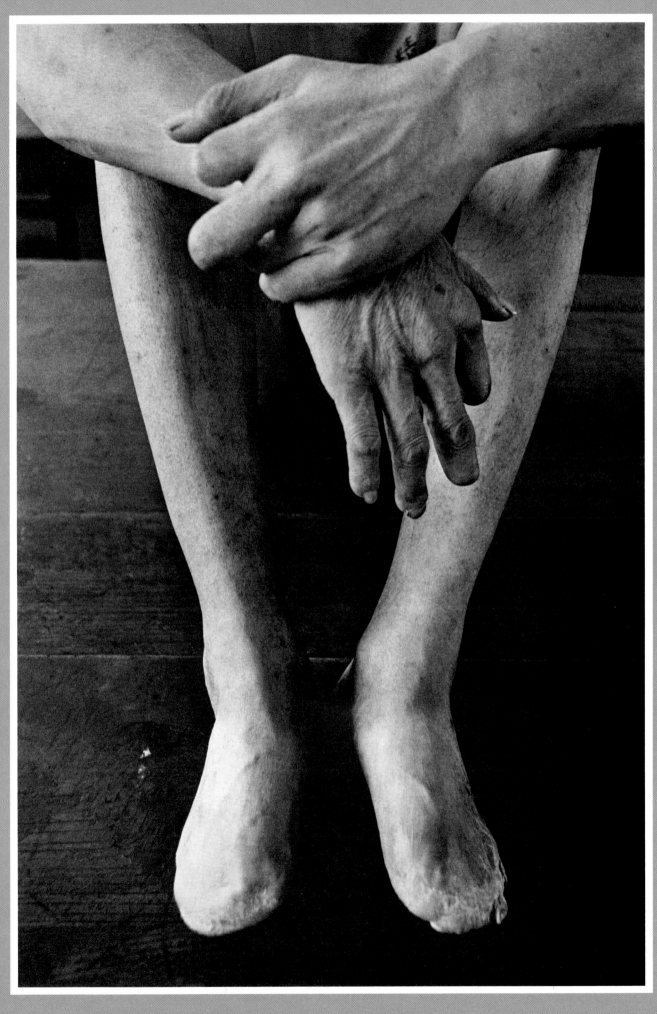

Opposite top: Tienjin, China, 1989. The woman lying in bed is Chang Shuwa, age thirty-eight, unemployed, traumatized eight years ago when she witnessed her husband hang himself at home. She had a father and two children. Her father became seriously ill three months before this picture was taken and that was when she was admitted. She was very thin when she first entered, but no medication of any kind was administered. She died ten days after this picture was taken. The figure looking out the window is a twelve-year-old girl suffering from severe mental retardation and albinism.

Opposite bottom: Tienjin, China, 1989. The little girl standing the bench, Qing Ying, age twelve, suffered from albinism and was severely mentally re-tarded. She had been transferred two years previously from an orphanage.

Right: Tienjin, China, 1989. Chin Jin-ming, age forty-five, a "three no" patient admitted for five years, had been deserted by his family over twenty years before. In the institution he had been exposed to the cold for so long that all of his toes and some of his fingers had dropped off. He did not live through 1989.

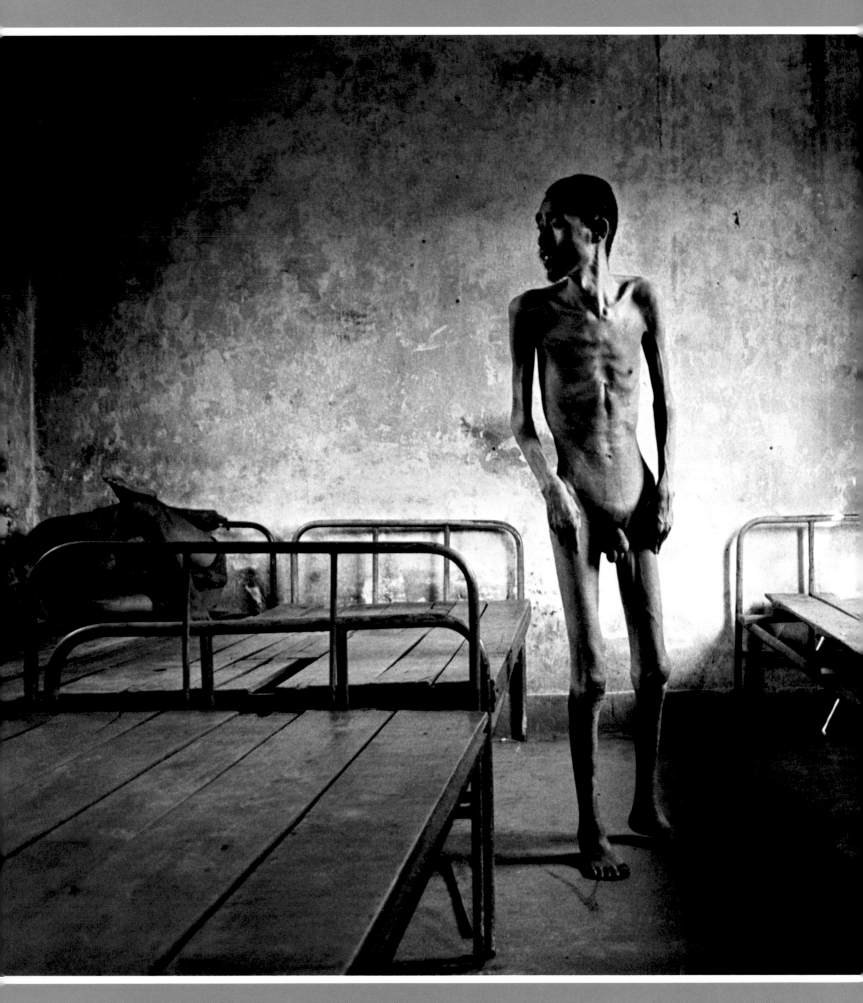

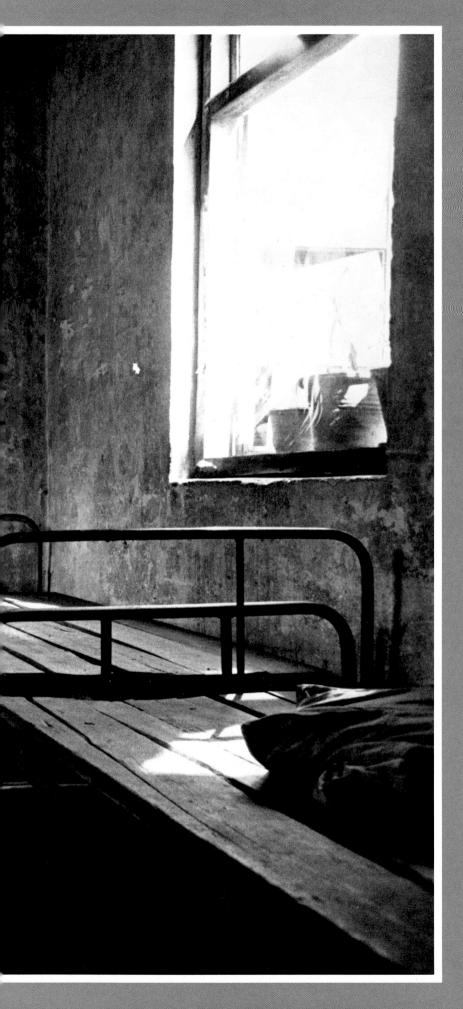

Left: Tienjin, China, 1989. Han Mun, age thirty-six, was unemployed, and had been here for six years. His father had a job, but the institution fee took half his wages. Han's elder brother was, at the time, in the late stage of liver cancer. "I don't know which son I should save first!" his father said.

Below: Beijing, China, 1989. A female patient admitted for just three days.

The rate of mental illness has risen in China by an estimated 60 percent in eight years. In a random sampling of high-school students, 25 percent have some kind of neurotic disorder. Beijing authorities report that mental illness is the primary reason students withdraw from colleges in Beijing.

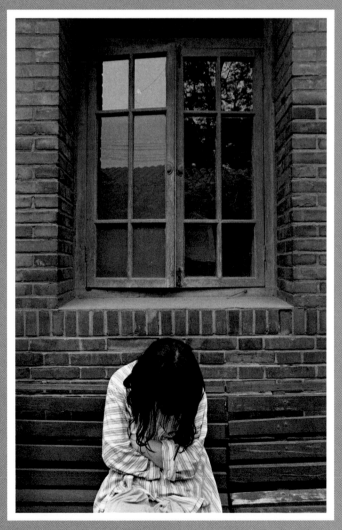

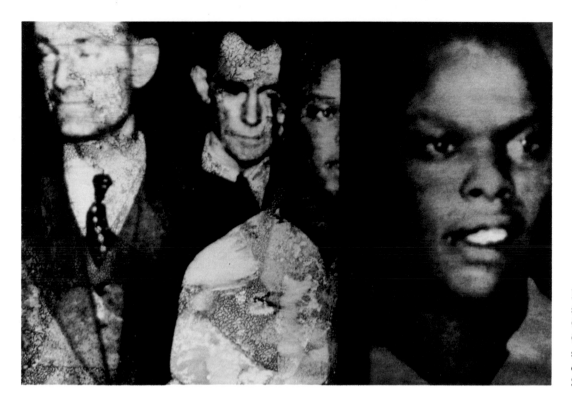

Left: from the
series "Another
Country," 1990.
Opposite: from the
series "Evidence
of Things Not
Seen," 1990.

CHRISTIAN WALKER

"White people thought that my work had reached a point where I was trying to make them feel guilty. And black people felt that I was bringing up some notions that should no longer exist in the culture."

Aperture: Has your work always been about racial issues?
Christian Walker: Well, I made a real switch when I moved from the Northeast to the South. The work before that was based on a more economic analysis of culture. When I got to the South, I saw that things are really divided along racial lines. I also shifted from a documentary mode to manipulated work.

The series "Another Country" and "Evidence of Things Not Seen" were made at the same time. I really wanted to juxtapose the work I was doing on the street with historical images of it. The images in "Another Country" all came from the National Archives. I rephotographed them and used the black line of the 35mm negative as a dividing line. It was a metaphoric device based on W. E. B. Du Bois's theory that the color line was the most important line of the twentieth century. Actually, the title came from James Baldwin's book, *Another Country*, which suggests that simultaneous countries exist in America.
A: How did "Mule Tales" evolve?
CW: When I was a kid, all of the books in my house were popular literature—such as *Mandingo* and *Drum*—that contained

African-Americans. There's a history of how African-Americans are contextualized by the dominant culture.

It occurred to me that minorities don't necessarily have jokes about the dominant culture. They have a lot of complaining and resistance but they don't have a lot of jokes. So I started doing some research in terms of jokes. I found some in the minstrel shows, and I found some really interesting books. There is a book called *Negro Jokes For Intelligent White People* from 1963, and a book called *Mule Tales In Its Relation to Dixie Darkies*, which was a 1942 Southern treatise on how happy the darkies would be if we'd just leave them alone! I coupled them with images from lurid paperback novels that all deal with either sexuality or violence. Again, a subject that comes up with me a lot is miscegenation and sexuality.
A: What was the reaction to your work?
CW: As for "Mule Tails," I got a lot of negative criticism from both black people and white people. White people thought that my work had reached a point where I was trying to make them feel guilty. And black people felt that I was bringing up some notions that should no longer exist in the culture. I do a lot of accusation or confrontation in throwing racist jokes out there. Actually, I prefer to call them "racialist jokes."
A: What's the distinction to you?
CW: I don't really see them as overt forms of racism. I see them as addressing the way that white people contextualize African-Americans in the culture. I feel firmly about taking a critical stance rather than an emotional stance.

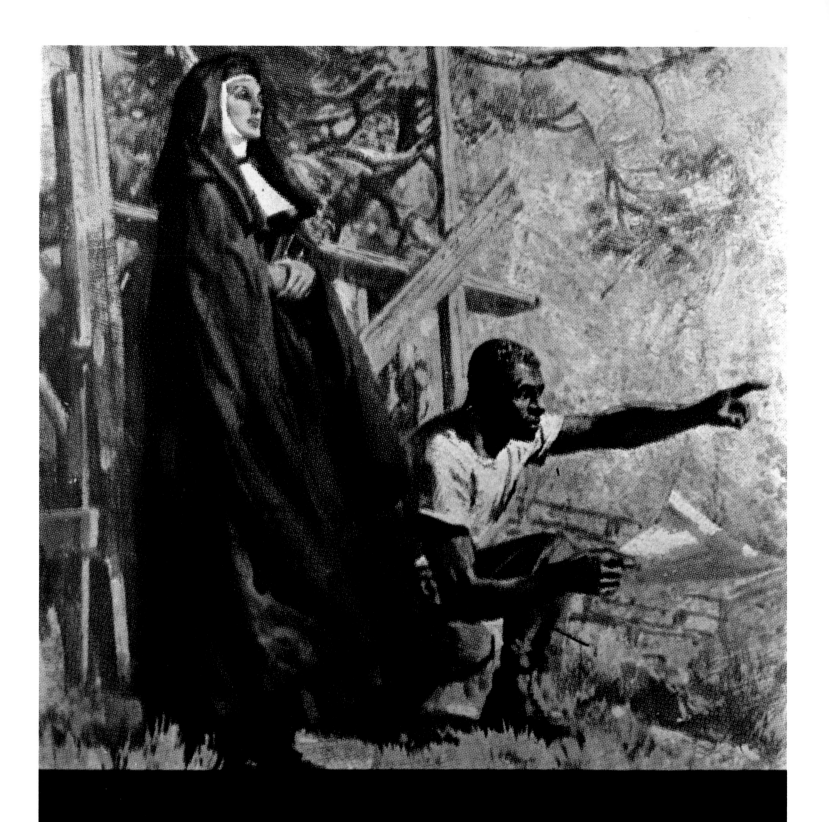

Mr. Bones: Mr. Interlocutor, sir!
Interlocutor: Yes, Mr. Bones?
Mr. Bones: Mr. Interlocutor, sir. Does us black folks go to hebbin.
 Does we go through dem golden gates?
Interlocutor: Mr. Bones, you know the golden gates is for white folks!
Mr. Bones: Well, who's gonna be dere to open dem gates for the
 while folks?

From the series "Mule Tales," 1992

What do you call one white man with several black children?

PROBATION OFFICER

From the series "Mule Tales," 1992

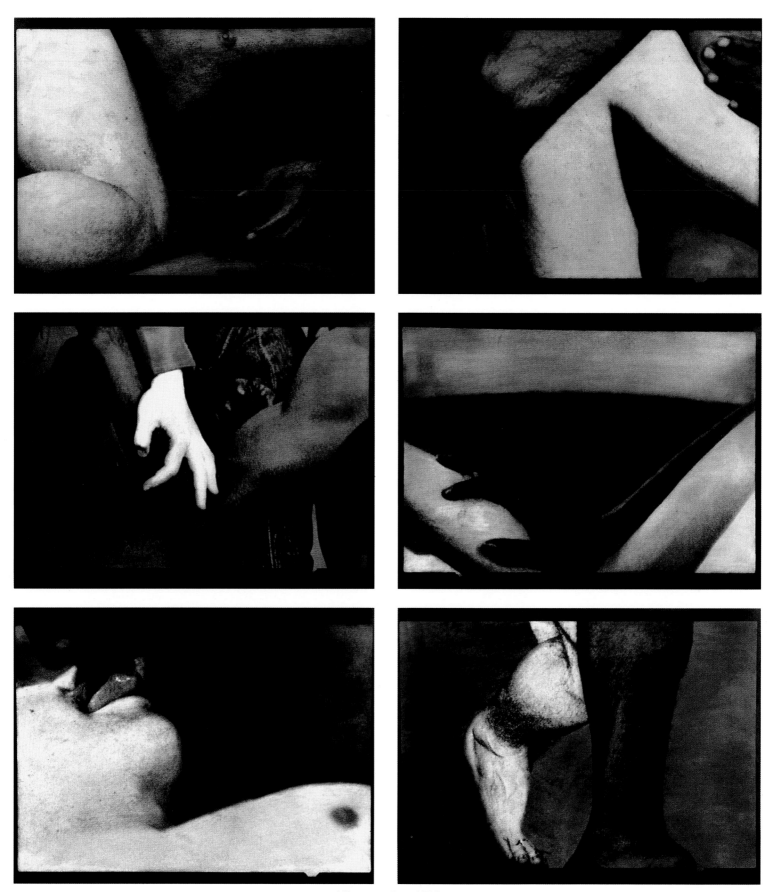

Miscegenation, 1985

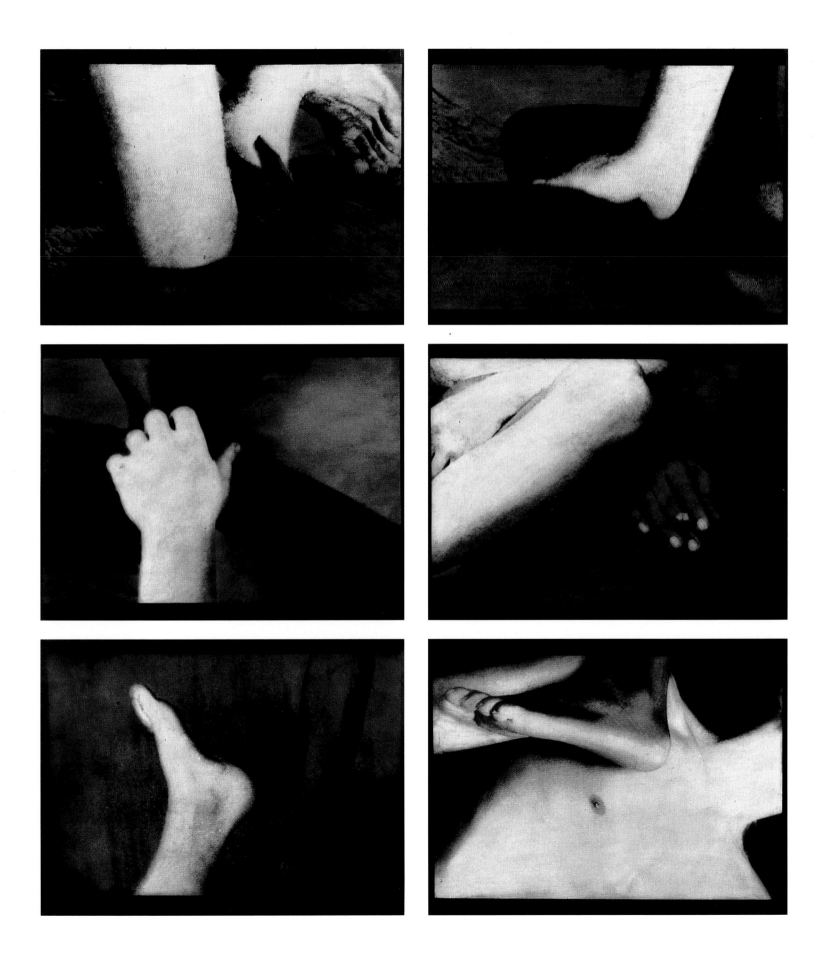

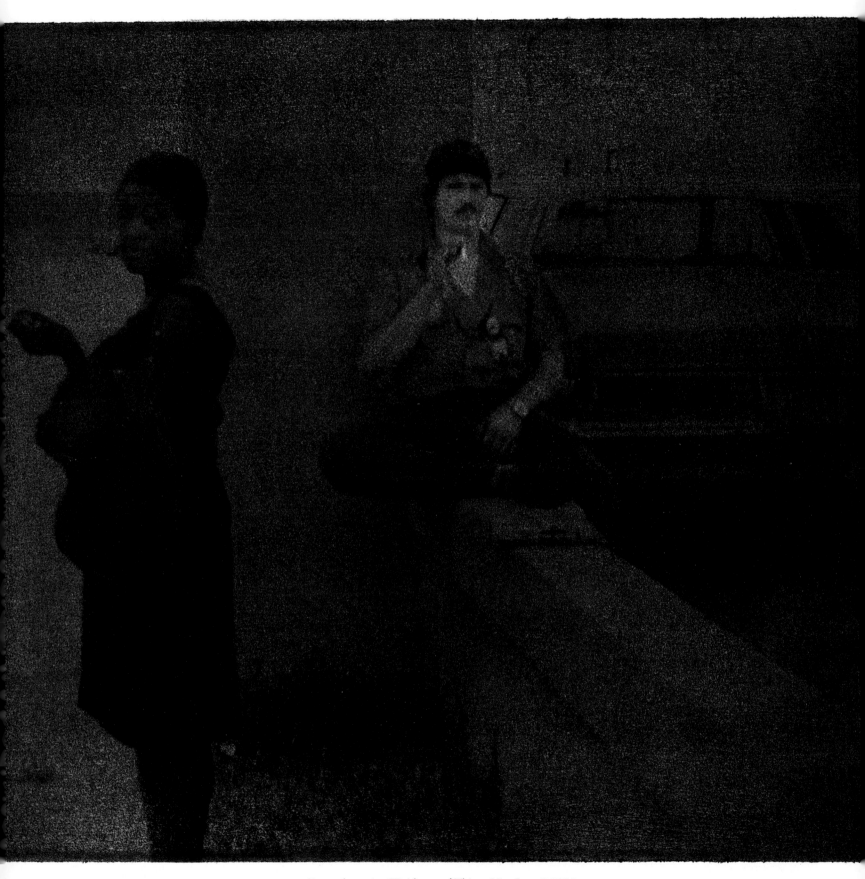

From the series "Evidence of Things Not Seen," 1990

From the series "Evidence of Things Not Seen," 1990

MARY KOCOL

"From a view through a window, several layers of reality are seen at the same time."

Aperture: How do you choose your locations?

Mary Kocol: I photograph where I live and in the homes of family and friends. I choose to work primarily at twilight, when the fading sky turns to sapphire and electric lights begin to glow. Vibrant and eerie lights and colors create a provocative scene. A once-familiar place becomes unusual, psychologically unnerving, and visually remarkable when night shadows emerge and objects give off their own light.

A: Why do you photograph windows and porches?

MK: From a view through a window, several layers of reality are seen at the same time: the area around the window, the world beyond it, and the glass surface itself, which can distort what is seen outside. At the window, the inside and the outside echo or confront each other. From the porch you get an elevated view of the yard and surrounding neighborhood. The porch becomes like a lookout point, or nest, yet it is attached to the house. The house sets the stage for the drama within the ordinary. It is where the delightful, the mysterious, and the disturbing come together.

A: How much do you focus on the technical aspects of your work?

MK: I've photographed this way for so many years that by now I could pretty much take a guess at where the exposure should be, judging by the light in the sky. And I work with color negative film, which gives me latitude to correct when I print. But it's more intuitive. I don't use a light meter at dusk. I actually need to use a light meter if I am working in daylight.

When I began I was really intrigued by flashlight photography, and I started out doing a lot of drawing with light. That led to using strobe units. Now I still use the strobe unit a little bit, but I'm mainly looking at the light that's available, ambient light, and how it changes.

Film can record the variable energies associated with the movement of light. During a long exposure, the film "remembers" the actions of light moving before it and saves these movements on one frame so that they are seen as if they occurred at the same time.

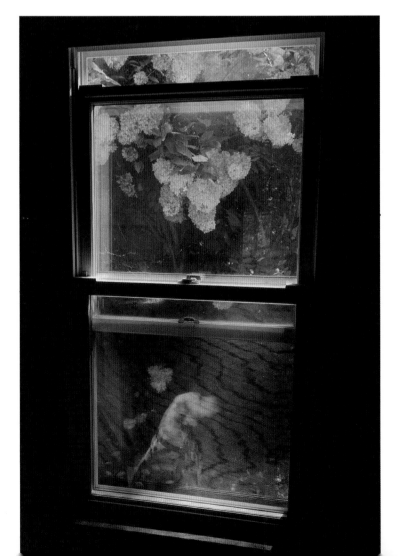

Left: *Astro's Reflection*, 1991.
Opposite: *Christmas Window*, Somerville, Massachusetts, 1989.

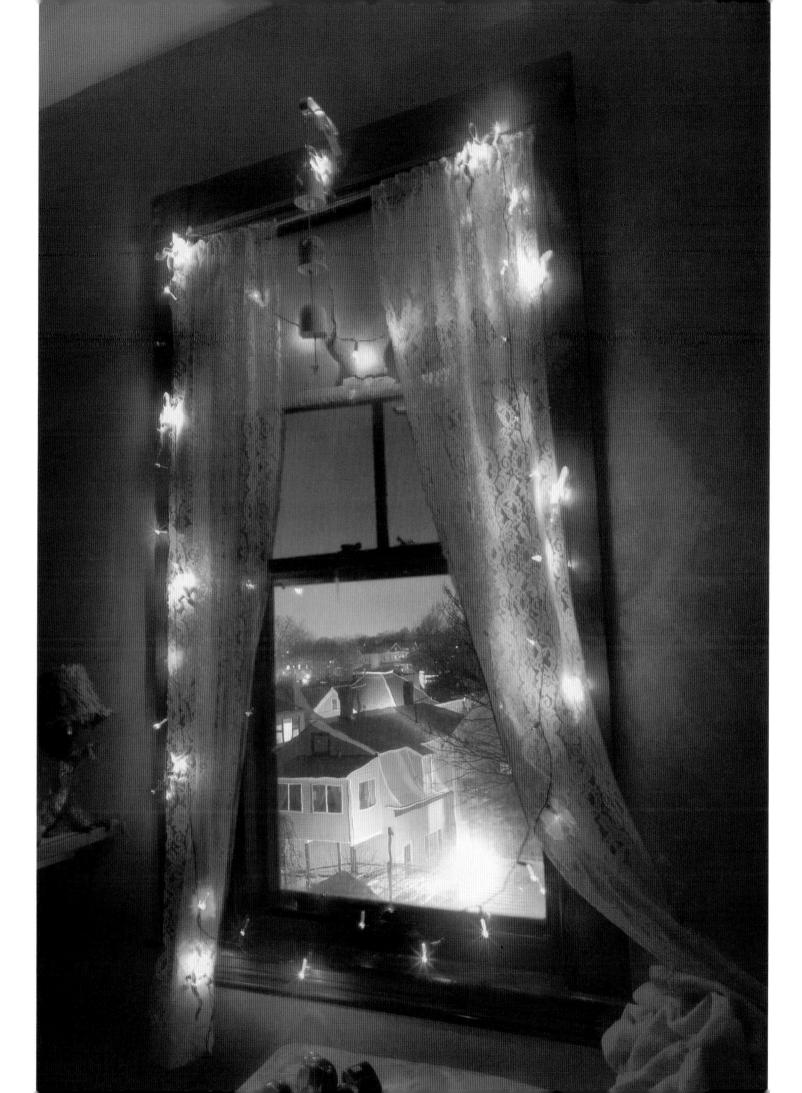

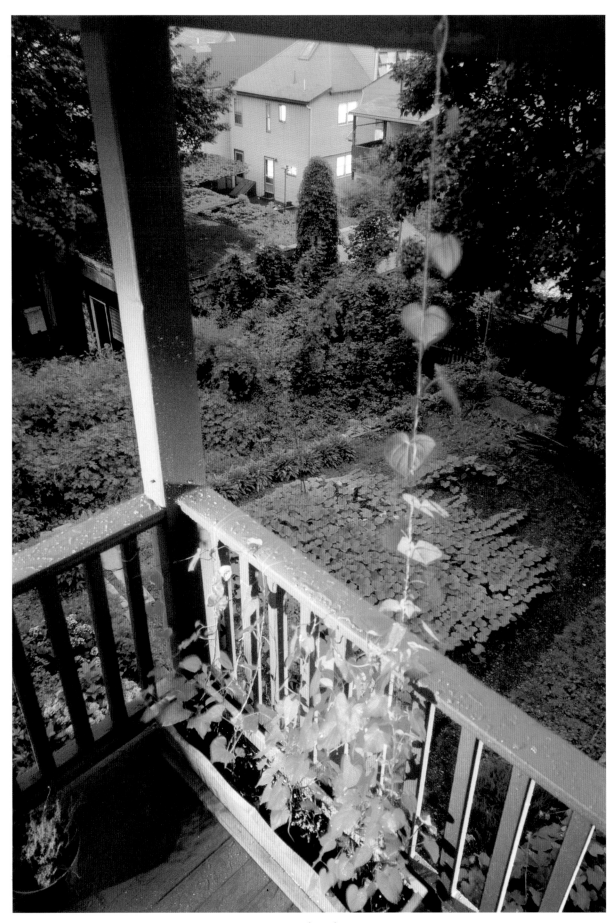

August Backyard, 1989

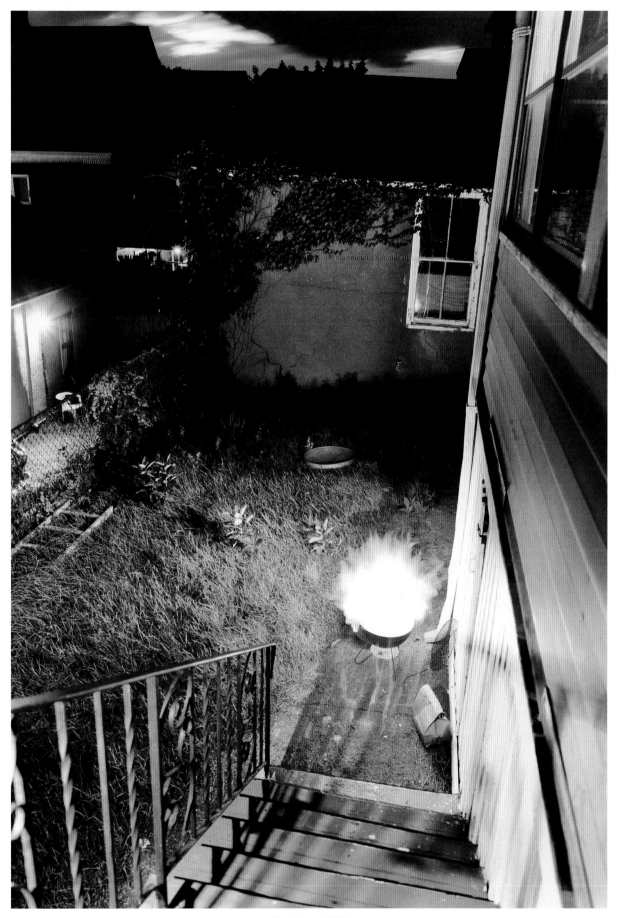

Cookout, 1990

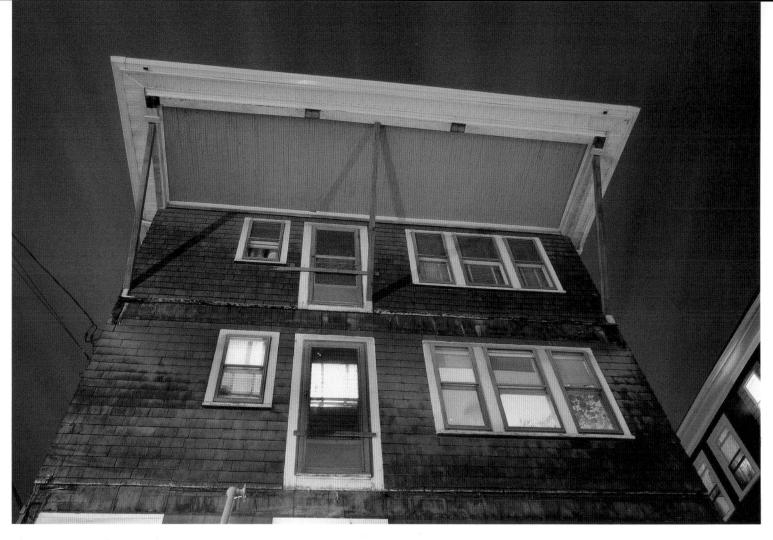

Above: *House Without Porches*, 1991. Below: *Stairway With Letters*, 1989 Opposite: *Spring Tree Shadow*, 1990

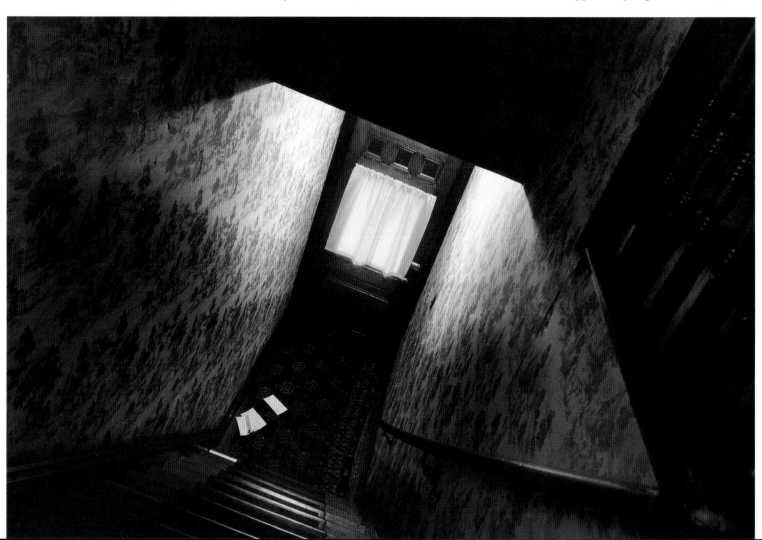

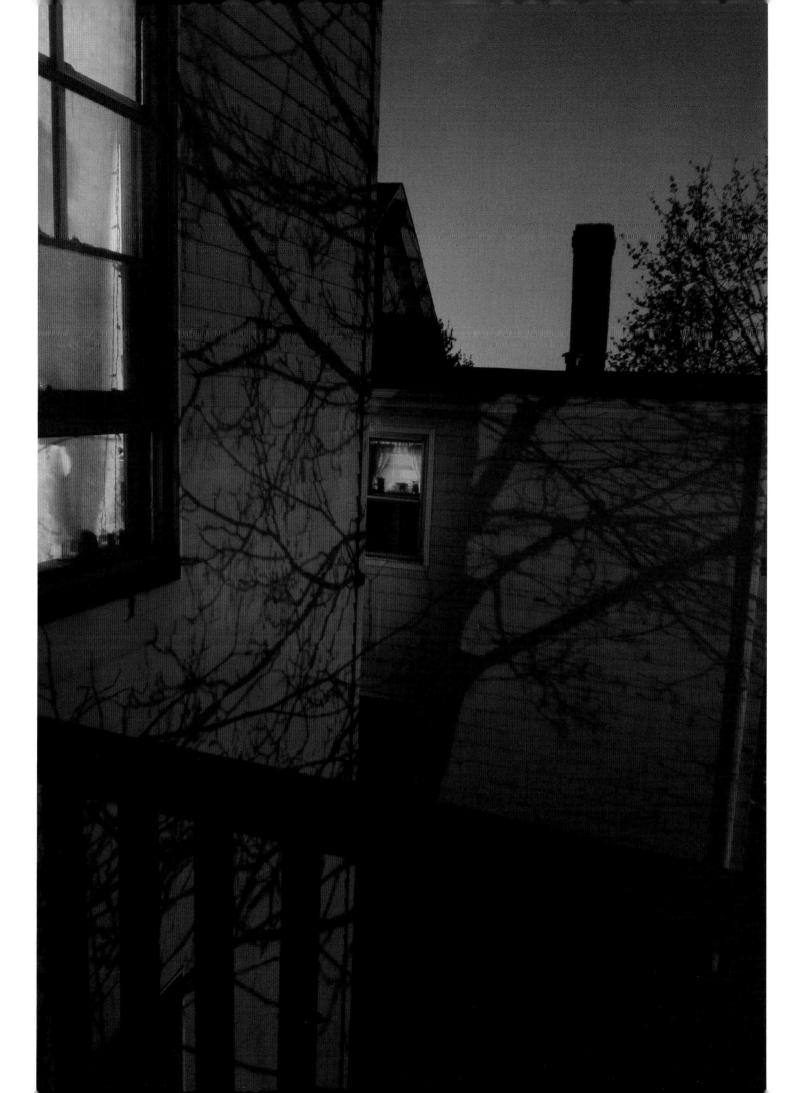

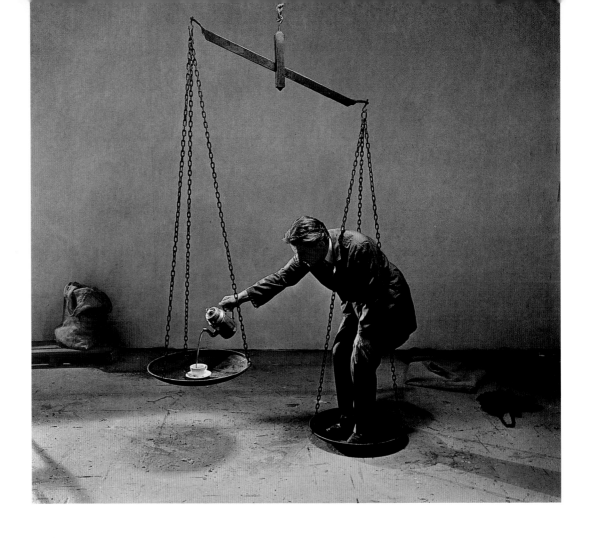

TEUN HOCKS

"Because the final result remains a photograph, there is a sense of reality that intensifies the situations depicted, making them more harrowing."

Aperture: When did you first pick up a camera?

Teun Hocks: When I was about twelve years old I was given a plastic Ilford camera. I am sure, however, I had touched my father's camera long before that. He was an enthusiastic amateur photographer. As a child I used to breathe down his neck in the blacked-out kitchen whenever he enlarged and printed photographs.

A: How do you create these unusual tableaux?

TH: For me, the way I work—in combination with the themes I choose—is something natural. Whereas many photographers wait for *the* moment and only then take photographs, I, like a painter, determine that moment myself.

Starting from the sketches I make—drawings of the situation as I wish to photograph it—I build and paint a scene, position myself in it, play my role there, and then take the picture in black and white. After blowing it up, printing it, sepia-toning it, and sticking it on wood, I use transparent oil paints to color the photograph. By the use of color I can enhance the atmosphere and create an extra opportunity for molding the situation to my will. My images represent emotional states that often illustrate the awareness of failing again and again. Because the final result remains a photograph, there is a sense of reality that intensifies the situations depicted, making them more harrowing.

A: Which photographers have influenced you most?

TH: I do not think photographers influenced me in the first place, but, rather, artists such as Goya, James Ensor, René Magritte, the cartoon artist Hergé, and the old Dutch masters. Artists like Christian Boltanski, John Baldessari, and William Wegman have influenced my choice to avail myself of the photographic medium because they demonstrated its many possibilities.

Above: *Untitled*, 1991–92. Opposite: *Untitled*, 1990

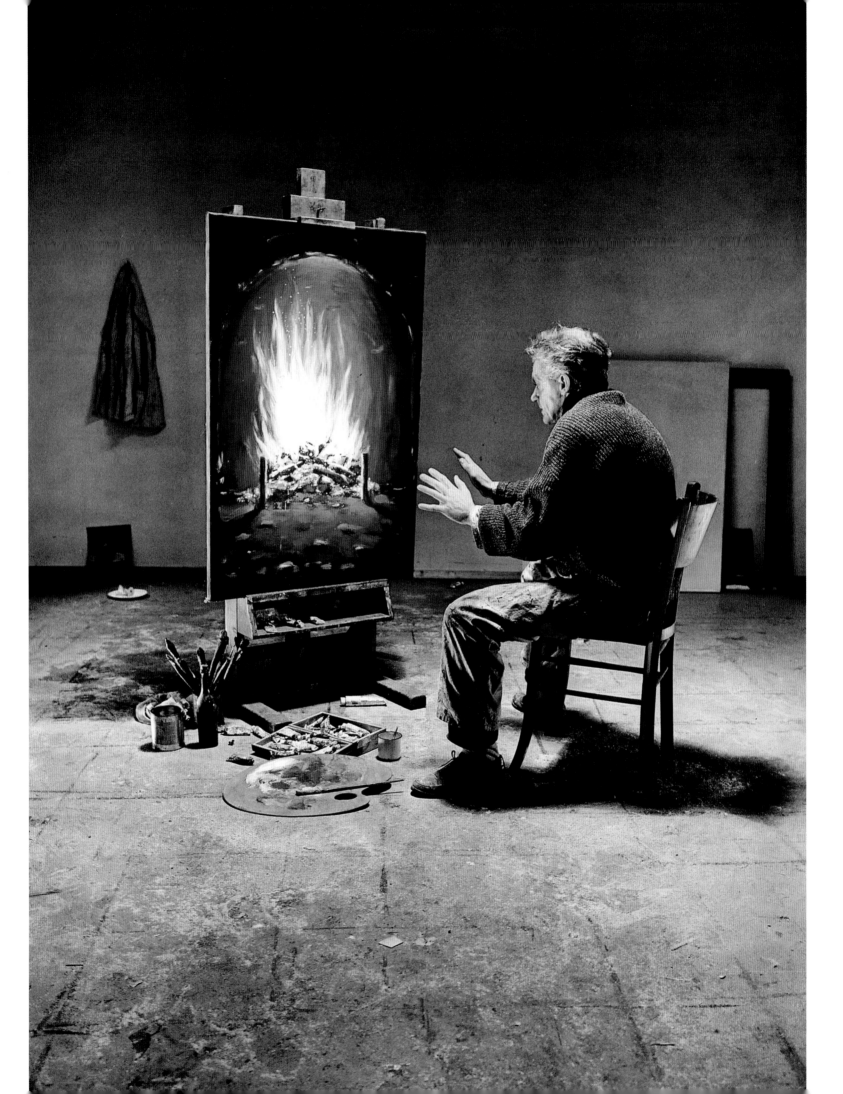

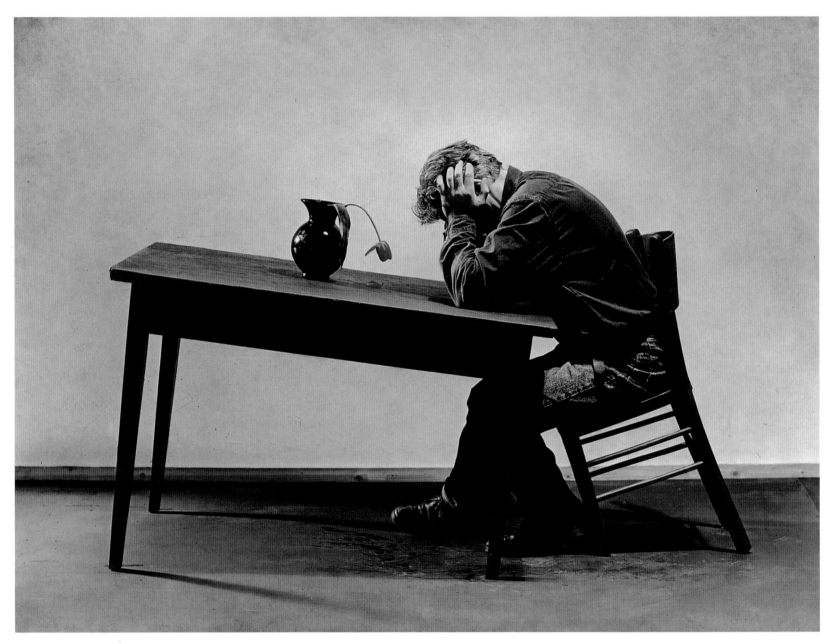

Untitled, 1989

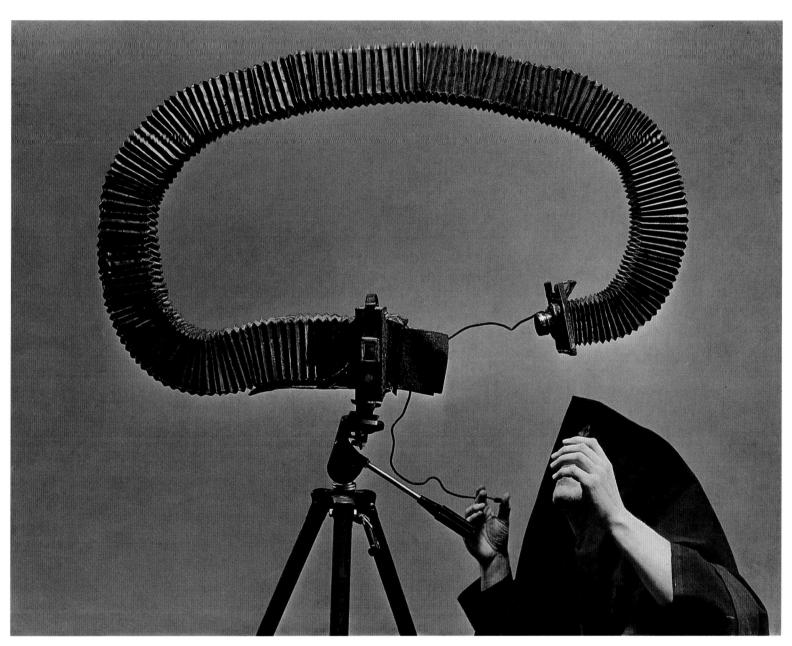

Untitled, 1990

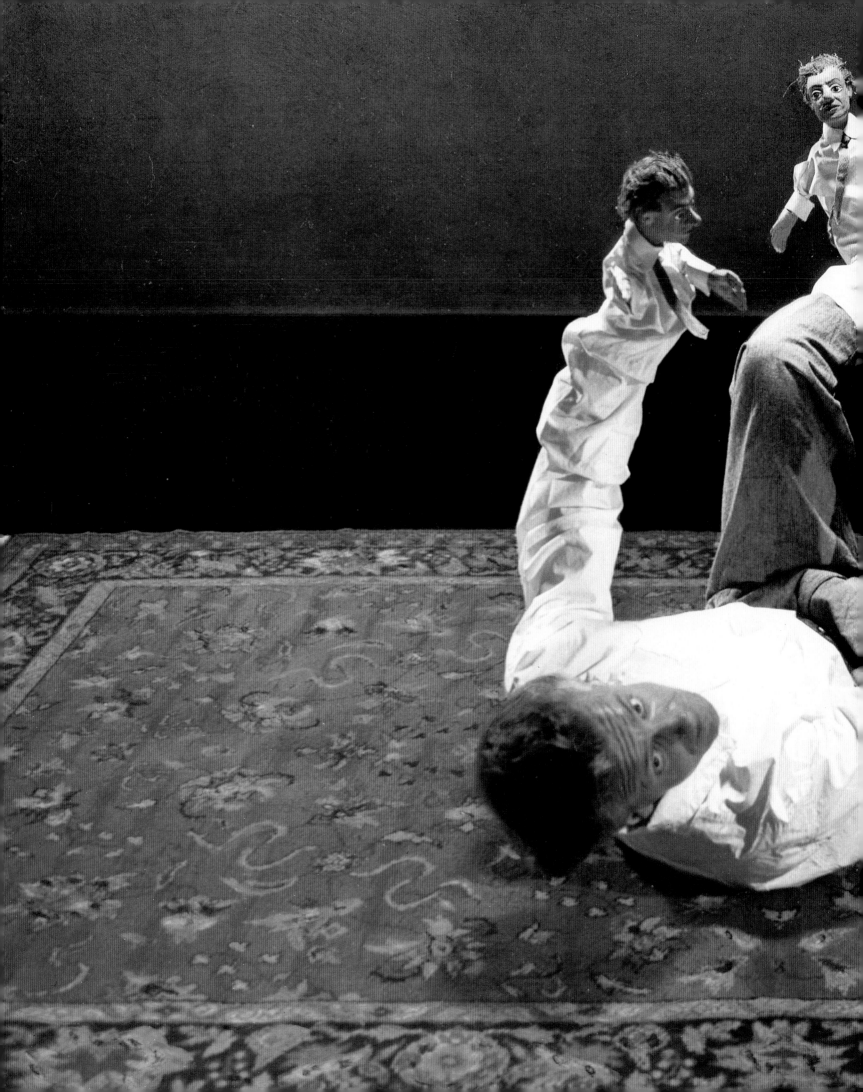

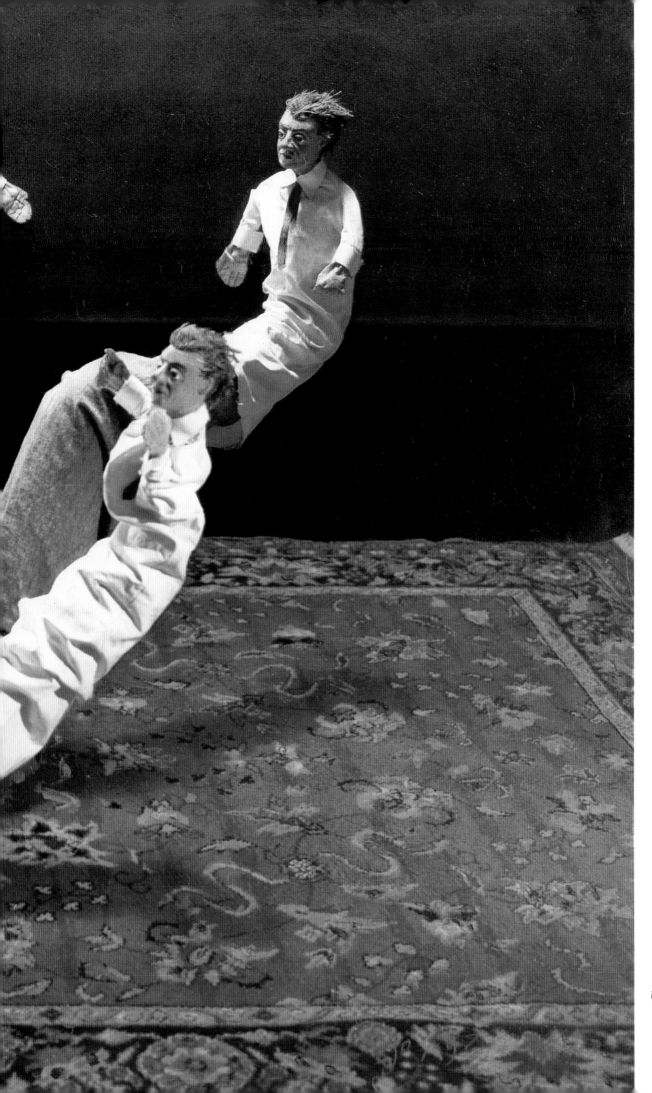

Untitled, 1990–92

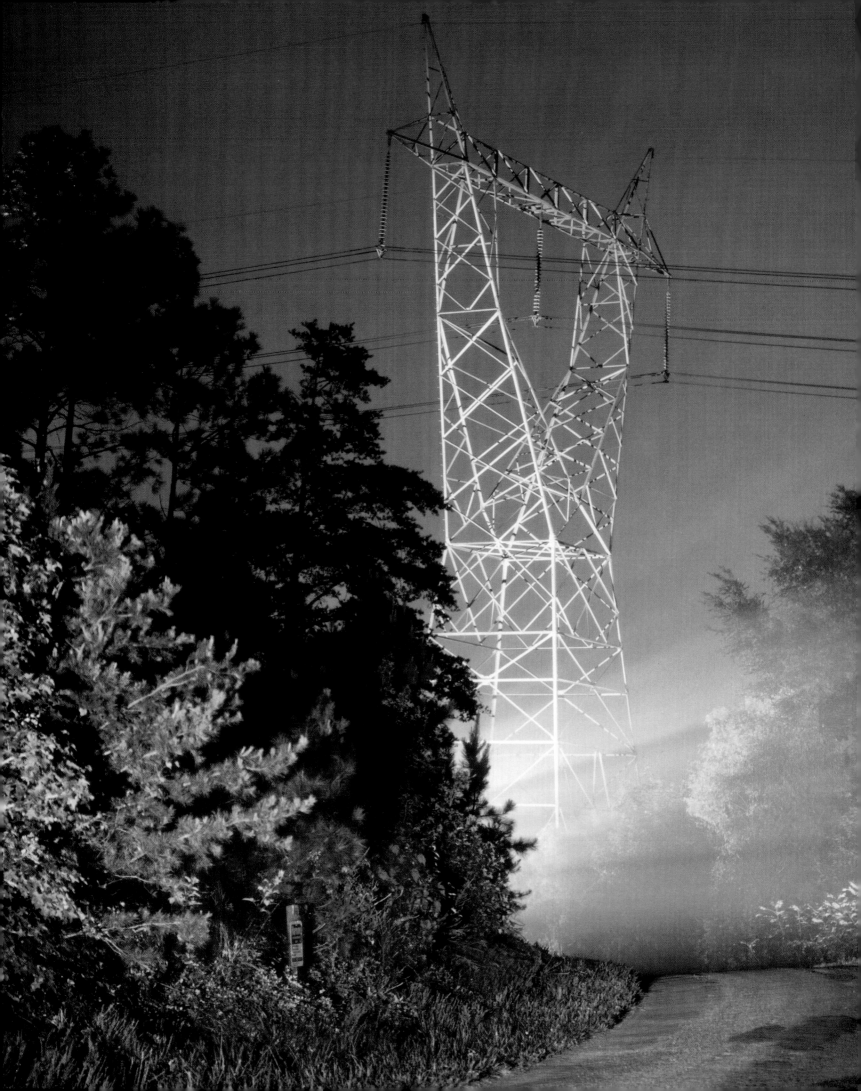

THOMAS TULIS

"I wanted to photograph towers around the country—in deserts, in the mountains, along the seacoast, in the swamps, and in all the other places that would make for a grand image."

Aperture: Why have you chosen to photograph these objects in the landscape?

Thomas Tulis: I tend to photograph those things that are close at hand, owing to the expense of travel. Transmission towers, cemeteries, and campaign signs certainly are close. So are railroad tracks, trees, bridges, water towers, and old cars. I've also photographed Civil War monuments, military equipment, farm buildings, farm equipment, and scenes with fireworks.

The transmission towers are my most extensive project since there are so many in such a variety of settings. At the time, I wanted to photograph these towers around the country—in deserts, in the mountains, along the seacoast, in the swamps, and in all the other places that would make for a grand image. But finances dictated that I stay close to home.

A: How did you start photographing the campaign signs?

TT: The campaign signs are some two or three years old, and are part of a series that I have yet to do anything with. I like to photograph houses, and the curious juxtaposition of these signs in front of them at night appealed to me. I also like the faces on these signs. There's a greater immediacy to this series of pictures, an up-close quality that was a change of pace for me.

A: And the cemeteries?

TT: The cemeteries were taken on three nights some three years ago using an 8x10 camera. I then made contact prints. I was able to play with the light and the exposures in some of these images. I've also done black-and-white photographs in cemeteries.

A: Are you working on any new projects?

TT: I may consider related subjects in the future: farm storage silos, school buses, boats in yards, rivers, mountains, and fields are possibilities. With increased lighting, I could try photography on a vast scale. I would also like to continue with my black-and-white work.

Transmission Tower with Road, 1989

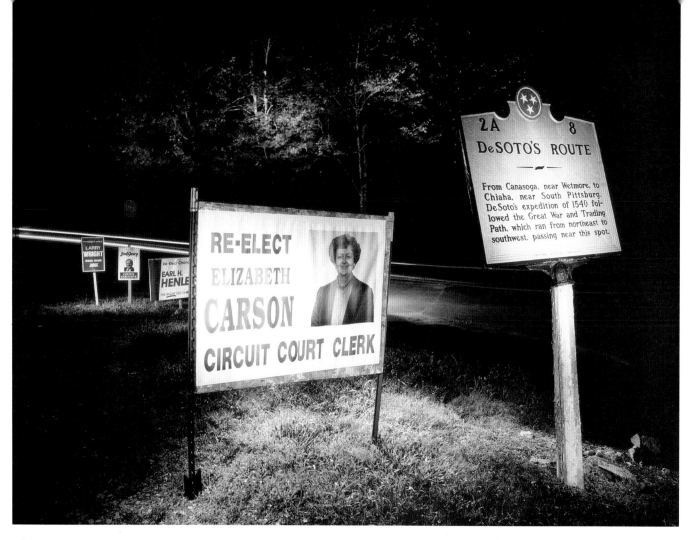

Above: *Campaign Signs #1, 1989*

Below: *Campaign Signs #2, 1989*

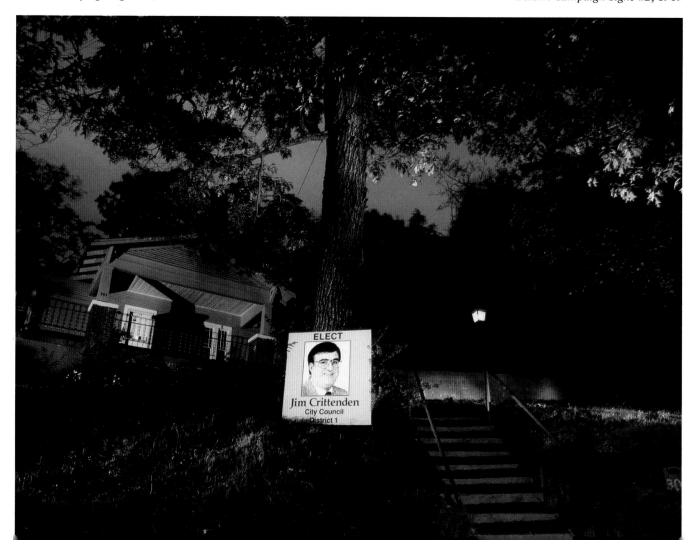

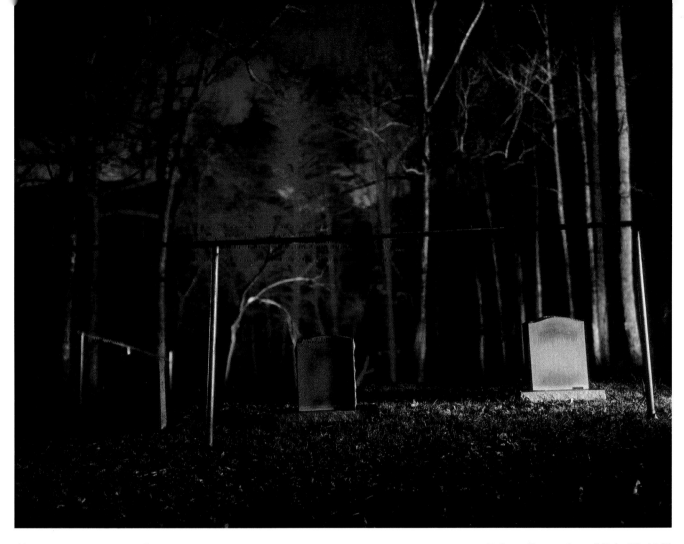

Above: *Cemeteries at Night #1, 1989* Below: *Cemeteries at Night #2, 1989*

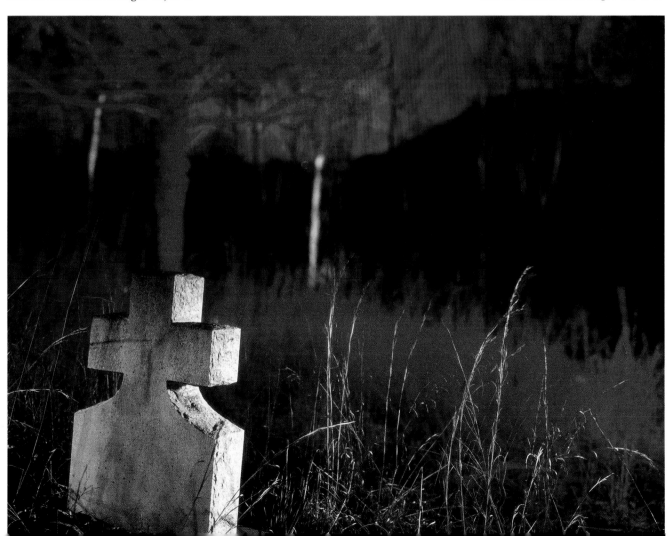

41

ANNE TURYN

"I am always curious as to what gender people assume the protagonist is. Is it male? Is it female? Do the pink Sno-balls mean it's female?"

Aperture: There seem to be thematic links to childhood in your photographs. Are they autobiographical?

Anne Turyn: These images are from "Illustrated Memories," a visual novel that I started in 1983. It's a fictional, visual autobiography that depicts a life through illustrated memories.

What I am really interested in, more than childhood, is how the brain works and how we remember. And it is during childhood that we learn the rules of society and culture.

A: You used the term "a visual novel." What does that mean?

AT: What I wanted to do was make something that would function like a novel, but instead of using language, it would use photographs. Rather than create a character that had a specific biography, I wanted to create more of an emotional resonance, so that if one were looking at the entire body of work, or a section of it, rather than a single image, there would be a kind of harmonic buildup.

A: Is there a plot to this visual narrative?

AT: No. Well, I'm open to meanings generated by the viewer. But I think that, given the seventy images I have in this body of work, I am controlling some of the readings by repeating certain imagery. For example, there's the favorite food, the favorite animal, the kitchen, and the TV.

A: What is the significance of the TV?

AT: Television affects the way we remember images. Because of TV, we see millions of images every day. I am interested in the light from the TV—when there's no longer an image and it's just light emanating from the set. When you go by people's homes at night, you see a blue light flickering in their windows, a kind of glow.

People leave TVs on when they're not home to make people think that they are home. I think of it as another light source.

A: What about the Hostess Sno-balls on the table?

AT: I guess I wanted some sort of sweet to be the favorite food, and I chose that one because of the color. I don't particularly like coconut, and I never did. But for formal reasons I chose the pink Sno-balls. I am always curious as to what gender people assume the protagonist is. Is it male? Is it female? Do the pink Sno-balls mean it's female?

All images are from the series "Illustrated Memories," 1983 to present

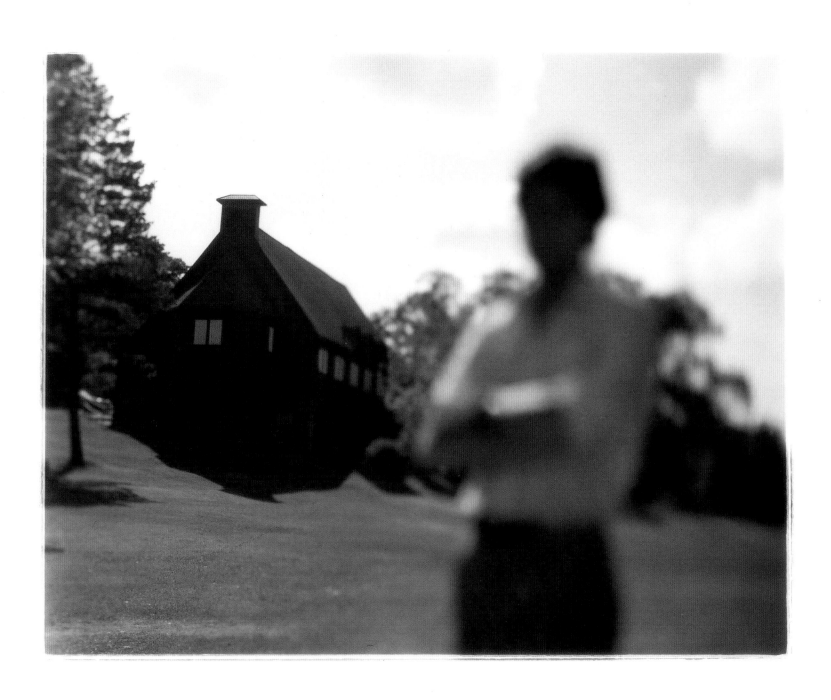

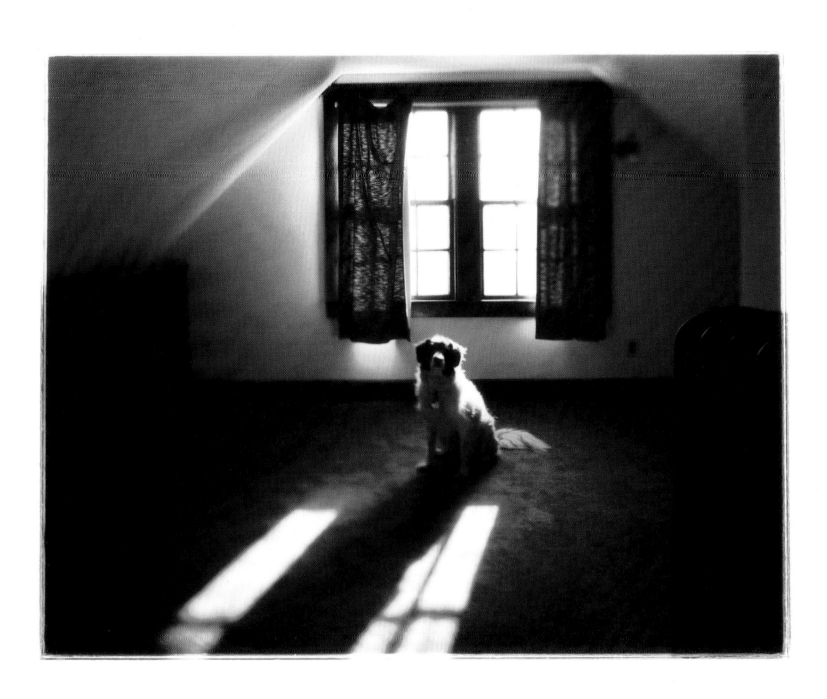

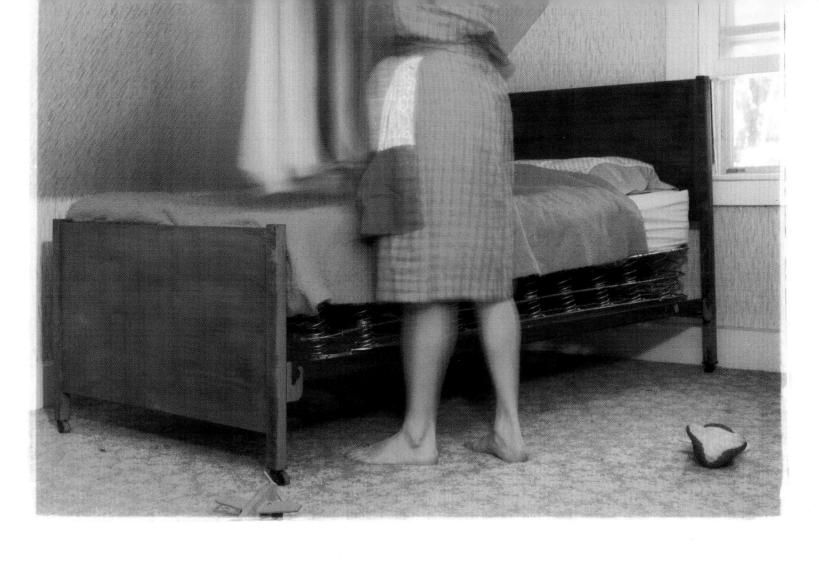

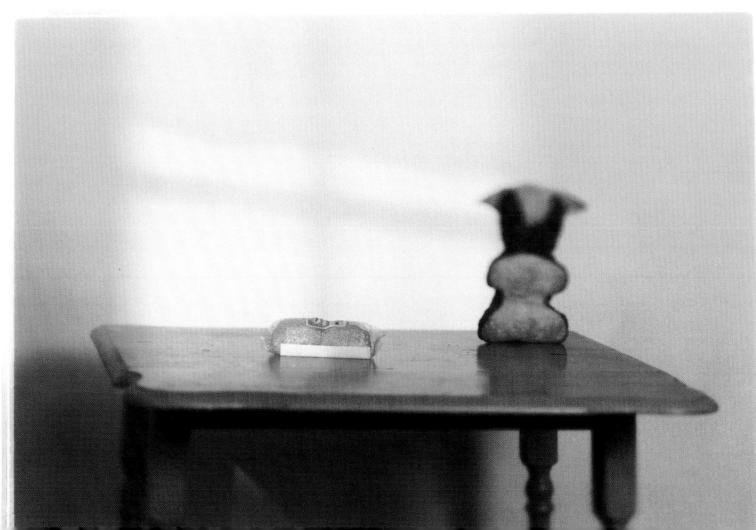

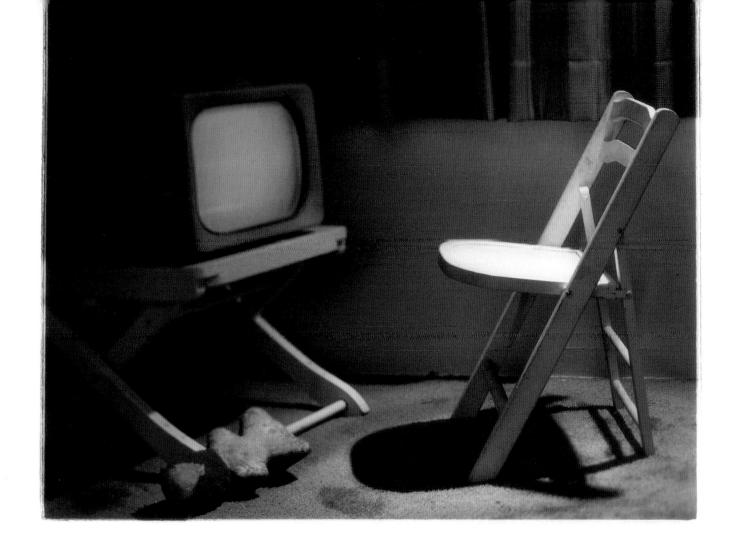

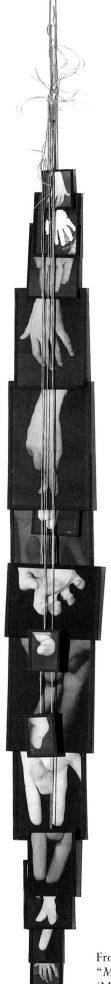

From the series
"*Mes Voeux*"
(My vows), 1988

ANNETTE MESSAGER

*"All the parts of one's life, all the
secrets, all the hopes, are in one's clothes."*

Aperture: Let's begin by talking a bit about your divided life as an artist, a collector, and so on.

Annette Messager: I give myself many titles. I wanted to be someone important, and the more titles we have, the more important we are. So I could be Annette Messager, Collector; Annette Messager, Trickster; Annette Messager, Practical Woman; Annette Messager, Artist. I think that we are many people at the same time.

A: Do you see this as a fragmentation or a synthesis?

AM: As a fragmentation—of time, and also as a fragmentation of the person...who is always, I believe, fragmented in a way. That's also what I love about photography, that it's a fragmented thing: you can either repeat it, multiply it, cut it, or reuse it. It moves along in time—as opposed to a drawing, which is always outside of time.

Along these lines, I have always been interested in taxidermy. For me, taxidermy and photography are the same thing: taxidermy takes an animal and freezes it, dead yet alive, forever. Photography also freezes—a sixtieth of a second—forever.

The person who is photographed is always killed in a way, fixed there for eternity. I think that photography has a lot to do with voyeurism. There is a kind of fetishism about photography that I find very compelling.

A: You see yourself as a trickster? How so?

AM: I believe that, first of all, every artist is something of a liar or a trickster. Artists play with reality, they make use of it, and at the same time, they are preserving it. Kafka said something great. Someone asked him what he thought about photography. He answered that photography is the trick you play on yourself. I did a series where I took some photos of bodies with little drawings on them. These were like games with the body, little fibs, or invented stories on the body. It's playing with the meager stuff one has: one's body, one's minimal vocabulary. I like to work with the body, because it's the one thing you possess, that you have from beginning to end.

A: Could you tell us about the series "History of Dresses"?

AM: For me, a dress, for the time it is worn, is like a second skin. It's something that is really very close to the self, and that is loved. All the parts of one's life, all the secrets, all the hopes, are in one's clothes. A year or so later, it's over, and you throw that skin away. So dresses, for me, are something very symbolic of the time of their wearing.

Translated from French by Diana Stoll.

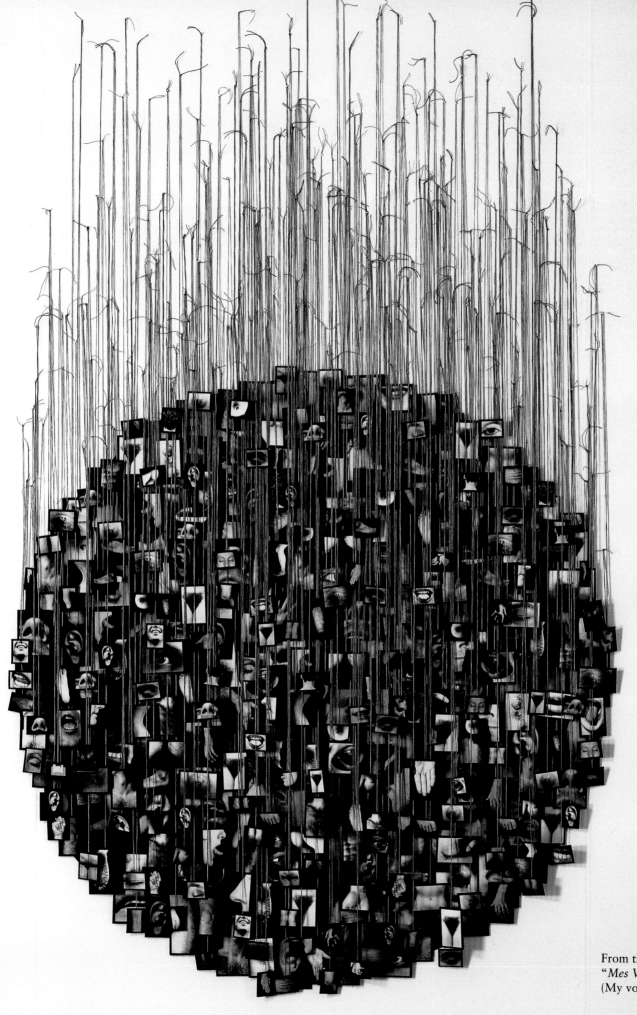

From the series
"Mes Voeux"
(My vows), 1990

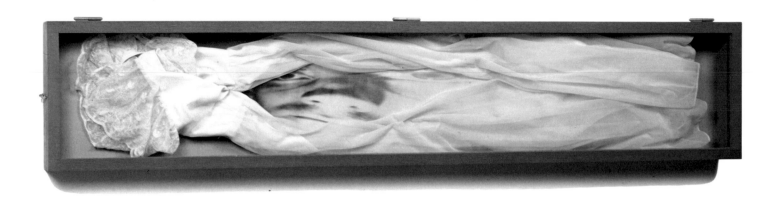

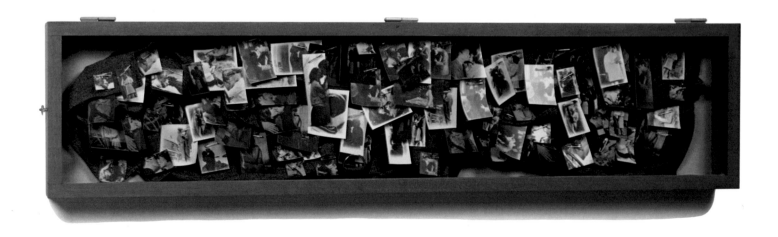

From the series "*Histoire des Robes*" (History of dresses), 1991

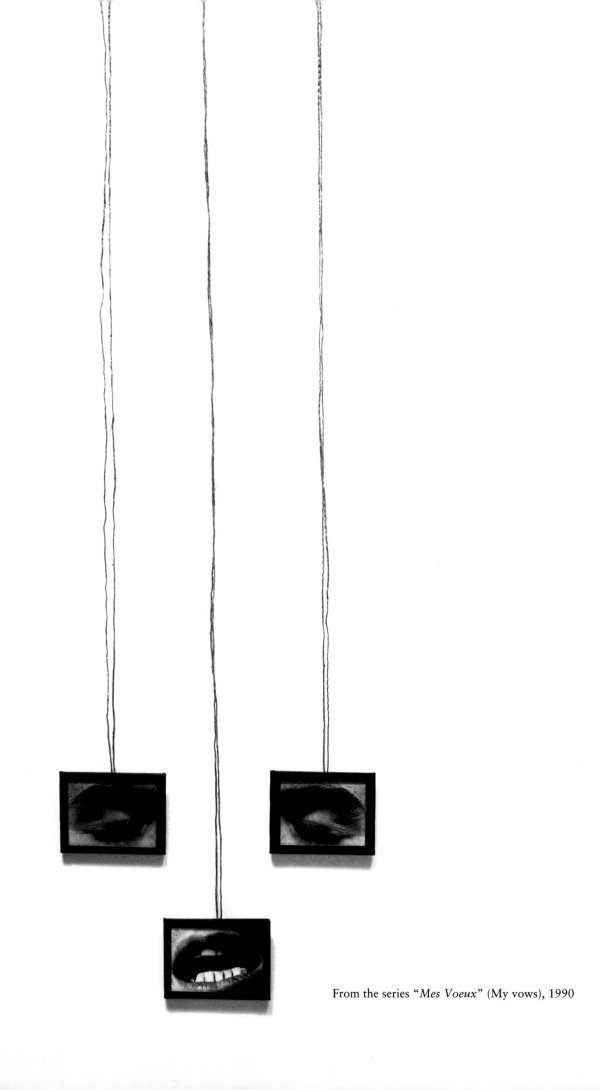

From the series "*Mes Voeux*" (My vows), 1990

From the series
"*Les Tortures Volontaires*"
(The voluntary tortures), 1972-1991

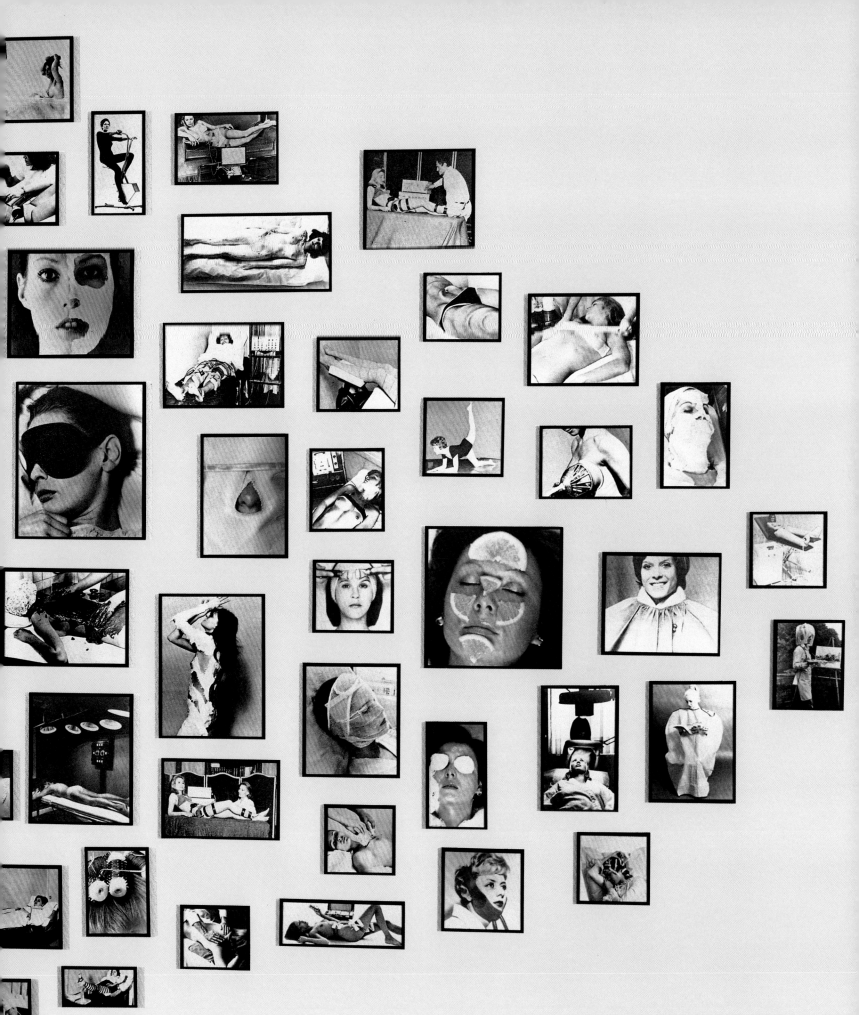

MICHIKO KON

"I feel the close presence of life and death in fish."

Aperture: How did you get involved with photography?
Michiko Kon: When I was a student in printmaking school, I thought I would try incorporating photographs into lithographic works. I made images by practically placing the lens next to the objects I was photographing and making collages of the results.

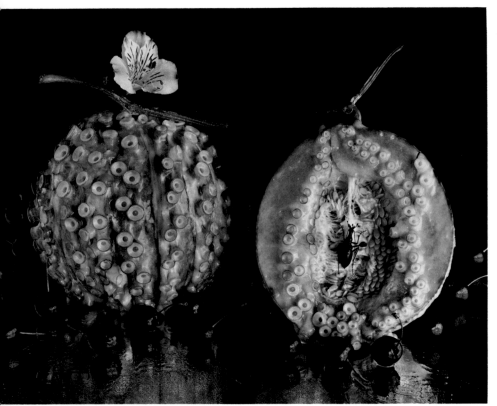

Photography was an extension of my painting and printmaking. At first I was mixing all sorts of things together, but it ended up just creating a kind of mood, which wasn't too interesting, and I guess I became drawn to photography itself.

A: Why do you use fish as a material?
MK: I'm interested in their textural quality, and I feel the close presence of life and death in fish.

Photography for me is not an everyday thing. Since photography can "fix" an object onto printing paper, the audience can easily recognize what it is. None of these are composite photographs, so the objects I made existed as a definite reality for several hours. What I like to do is create an unrealistic situation through an intensely direct, unambiguous method. I do not want the viewer to grasp an object with dull, insensitive, everyday eyes. The reason I often use fish, plants, insects, and human bodies as subjects for my photography is because life contains a delicate beauty that attracts other objects, and has a time limit. I have a desire to stimulate people's five senses, and transfix them with a photograph.

A: Which photographers have influenced you most?
MK: Since I came to photography through other media, there are photographers I like, but I wouldn't say I have been influenced by any. As for photos, I like Edward Weston's *Neil*, 1925. I thought it was a marble sculpture at first. I don't like the pictures Weston took of women, but I do like his boys. I like the body when it's still halfway, not yet an adult, without the differentiation of male and female.
Translated from Japanese by Jordan Sand.

All photographs from the series "Eat." Above: *Octopus and Melon*, 1989. Opposite: *Self Portrait*, 1990

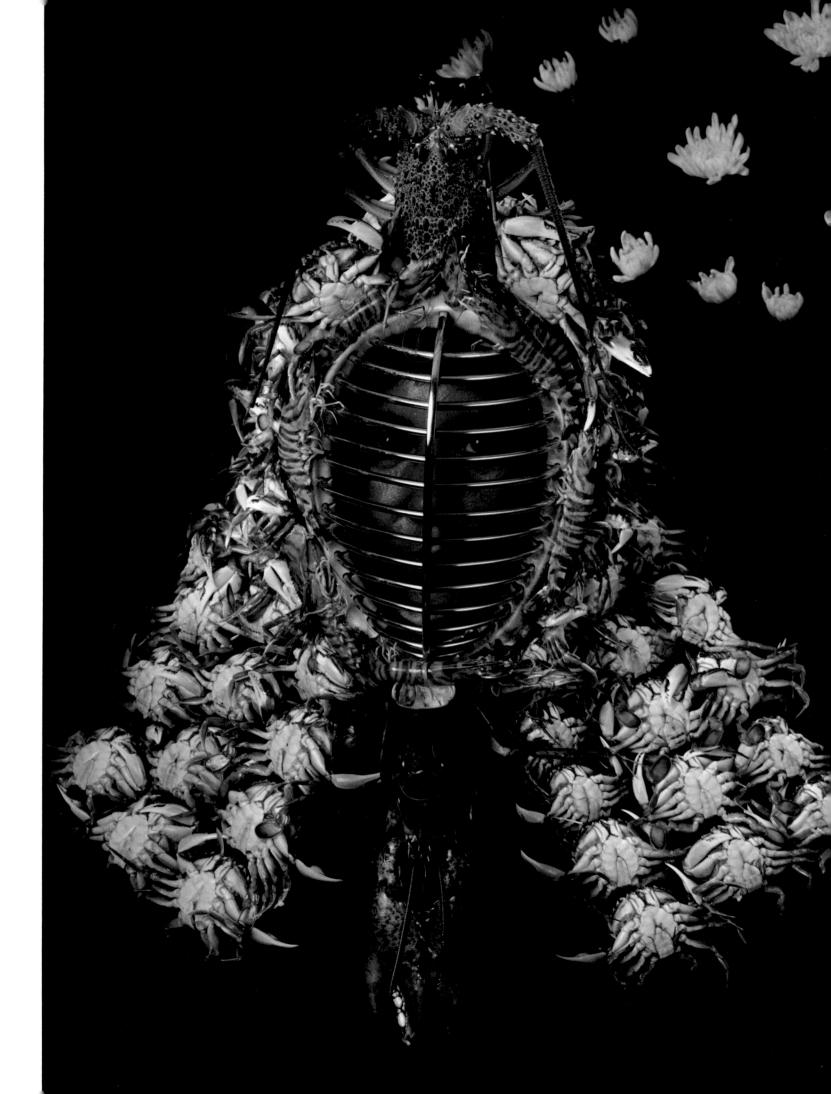

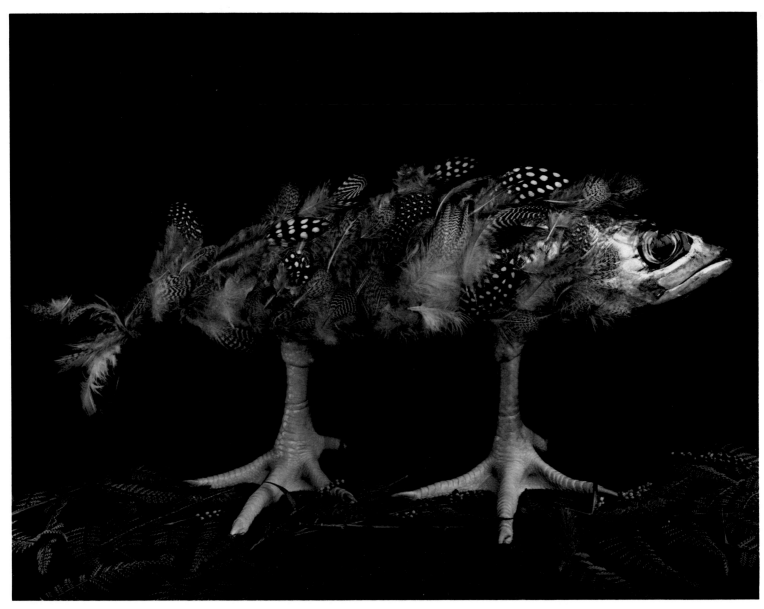

Mackerel and Chicken Leg, 1990

Opposite:
*Papaya, Halfbeak,
and Teeth*, 1989

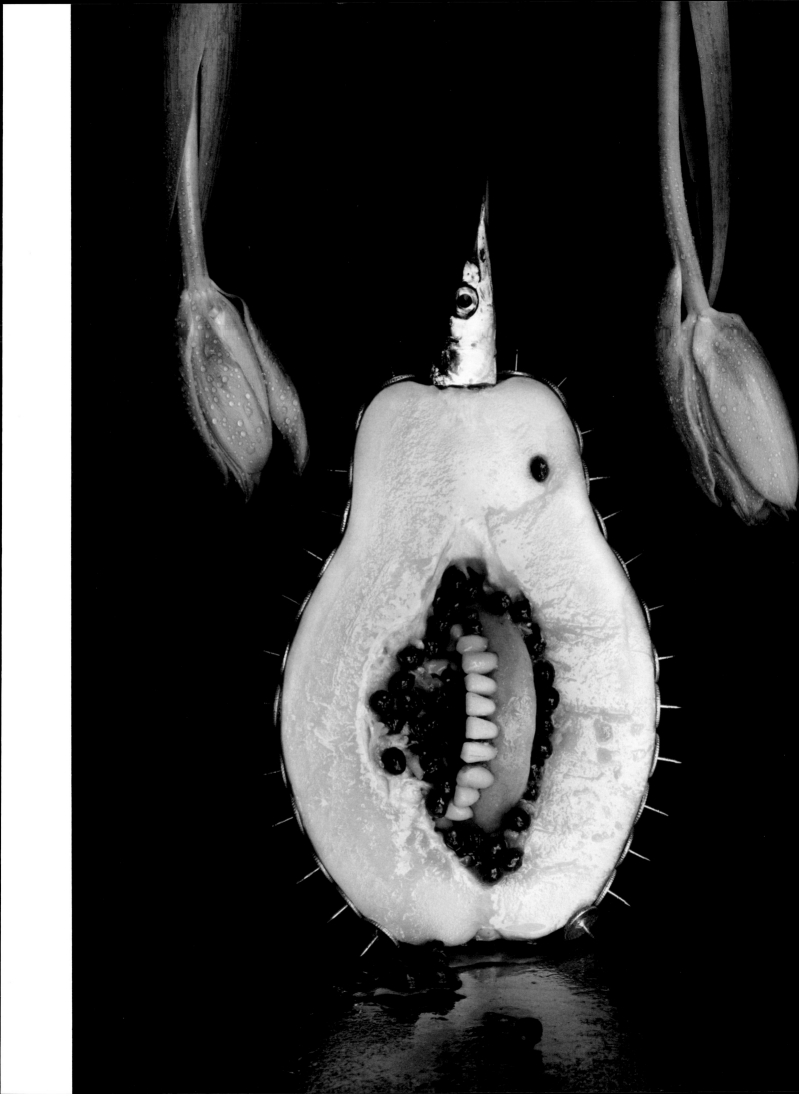

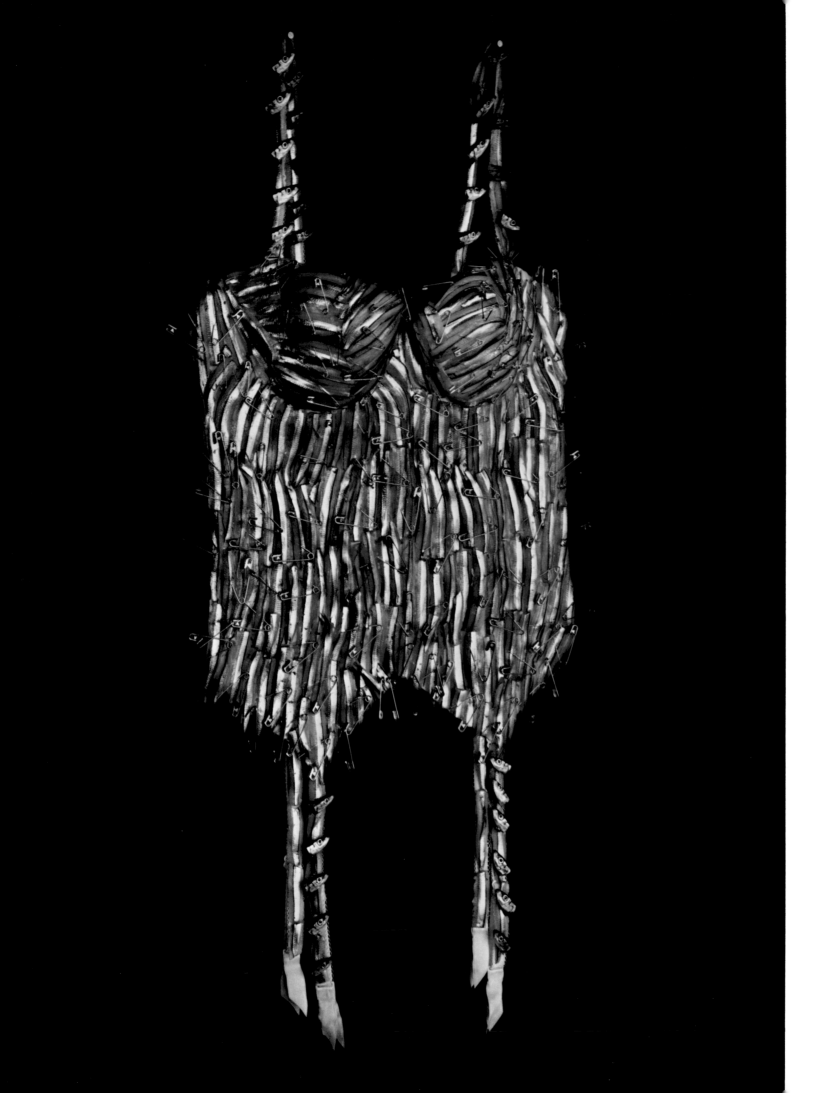

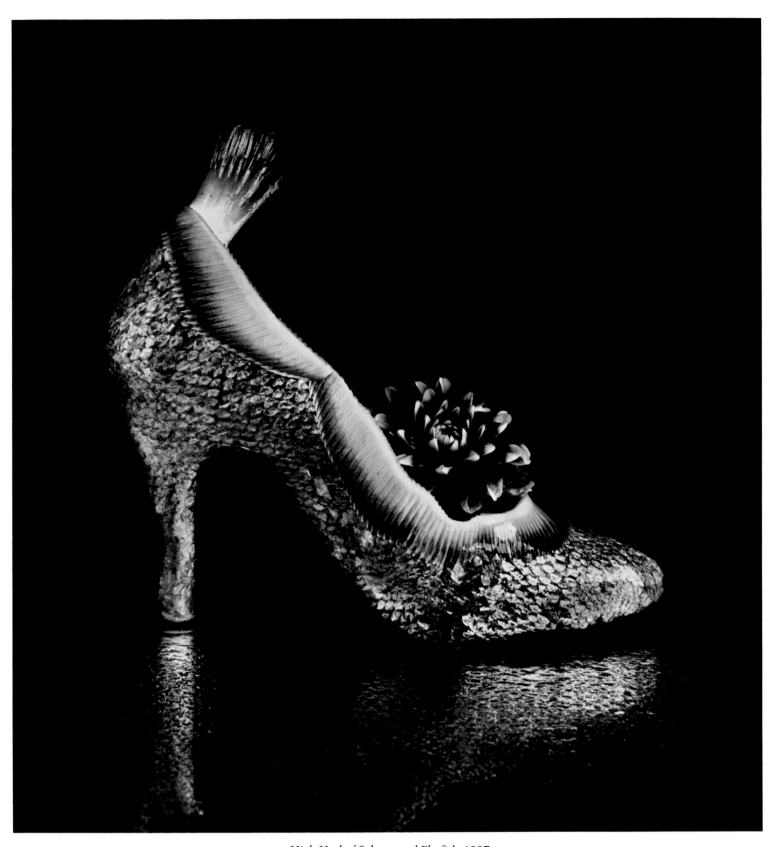

High Heel of Salmon and Flatfish, 1987

Opposite:
*Lingerie and
Pond Herrings*, 1989

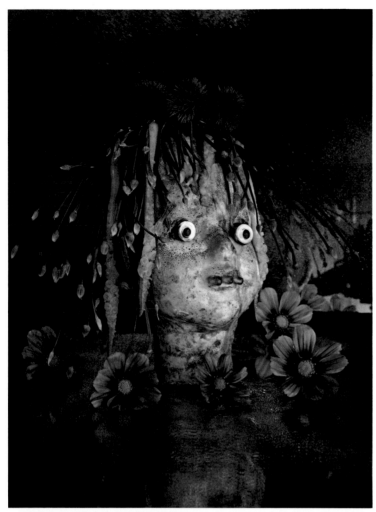

Cuttlefish, Scallions, and Girl, 1990

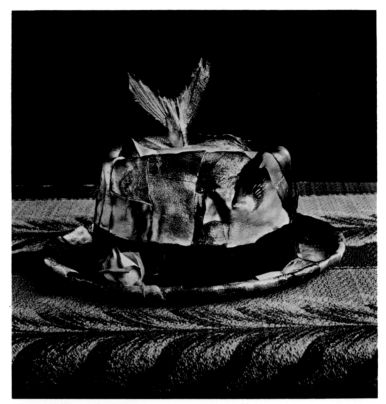

Hat of Yellowtails, 1986

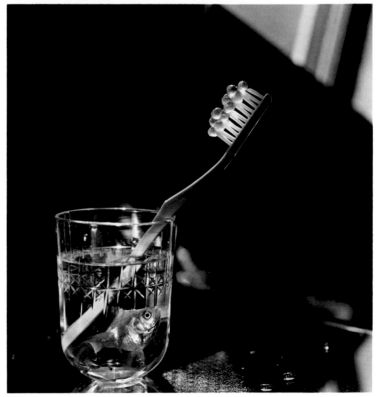

Goldfish, Salmon Roe, and Toothbrush, 1985

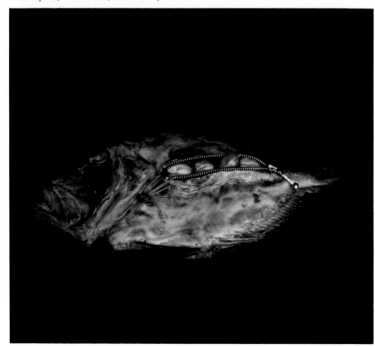

Sea Bream with Zipper and Poppy Seed, 1987

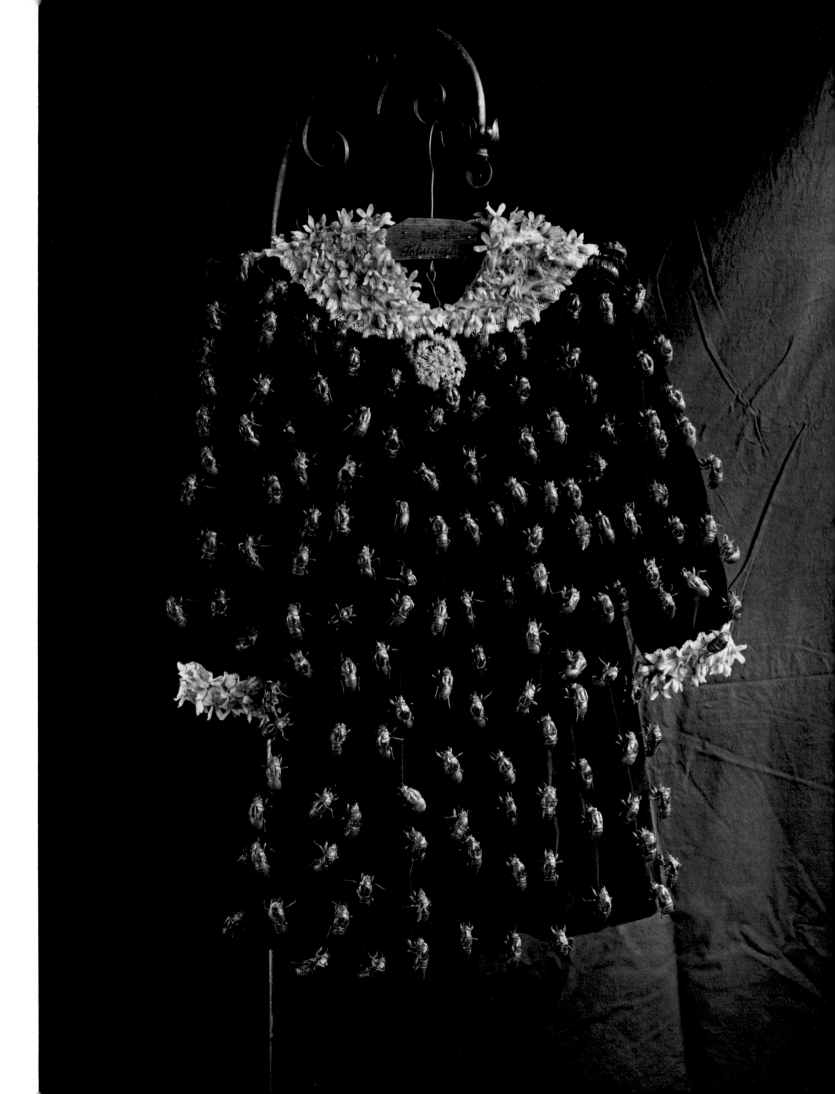

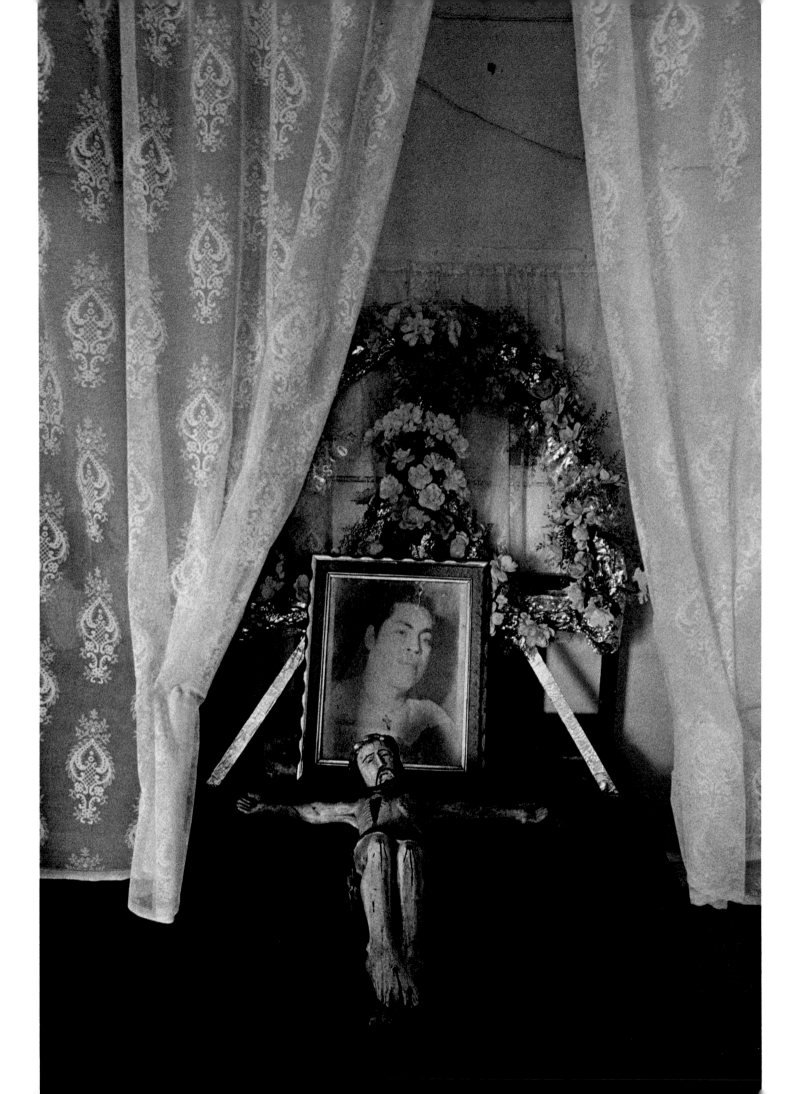

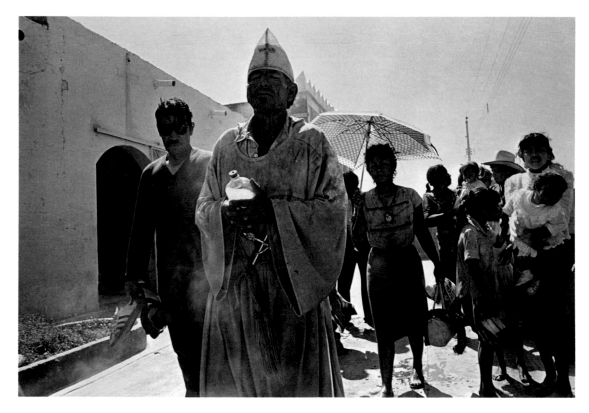

Opposite: *The bed of Niño, inside the* tumba, Espinazo, Nuevo León, Mexico, 1987.
Left: *El Cajon leading his mission, El Camino de penitencia*, Espinazo, Nuevo León, Mexico, 1987

DORE GARDNER

"I needed to understand the relationship between healing and faith."

Aperture: How did you begin photographing healing?
Dore Gardner: I had been photographing here in Boston in Baptist churches and at "tent revivals," as well as at ceremonies in Georgia and South Carolina, with priestesses and preachers doing mass healings. I was interested in the issues of healing and faith. The concept of faith has always perplexed me.

I found out about Niño Fidencio through a film by Nicolás Echevarría called *El Niño Fidencio*. In 1986 I went to see it twice. It had old footage of the Niño healing in a village called Espinazo, in Nuevo León in Mexico. I was absolutely taken by the Niño's image and his gaze. I wanted to find out who he was with the idea of including the *curandero* (folk healer) with my other work. I needed to understand the relationship between healing and faith.

In 1987, in March, I went down to Espinazo. After eight hours on a dusty train, I arrived. When I started photographing, the images were powerful, but what was even more provocative were the stories I heard about Niño Fidencio. At a young age he began to show a remarkable capacity for healing. He would work in the tradition of the indigenous healers, with herbs, plants, and in mysterious ways with the supernatural. At the time he was living, thousands of people would come to this remote village. He was well-known, especially along the border in Texas. Texas newspapers have stories about a great faith healer that lived in this village.

Though he died in 1938, hundreds of people invoke his spirit, because he said he would be back spiritually in the bodies of what he called *materias* (female) or *cajones* (male mediums for his spirit). Thousands still seek his cures on both sides of the Rio Grande.

A: One of the reasons you went was for the big fiesta. What was that like?
DG: The village swells with people. Normally, only about two hundred and fifty people live in the village, but during the fiesta it grows to 40,000. The followers of the Niño do what's called *penitencia*. There is a tree called the *pirulito* tree, which is near the edge of town. The *pirulito* tree is where Niño Fidencio was supposedly given his special gifts or powers from God.

There is a ritual among those who attend the fiesta of walking around the *pirulito* three times when they come into town, or before they start their *penitencia* up to the *tumba*, or tomb, where he's buried. For about two hundred and fifty yards of rough, dusty, stone road, they walk, crawl on their knees, or roll, to do *penitencia*, to ask the spirit of Niño to heal someone, to heal themselves, or to thank him for healing somebody.

I have a great deal of respect for people who can believe so strongly in something that it gives them strength.

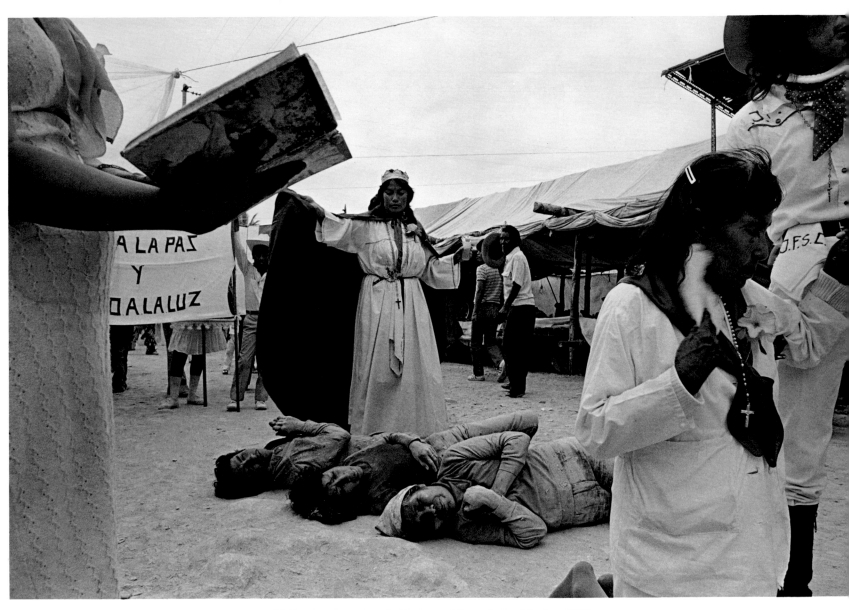

El Camino de penitencia, Espinazo, Nuevo León, Mexico, 1987

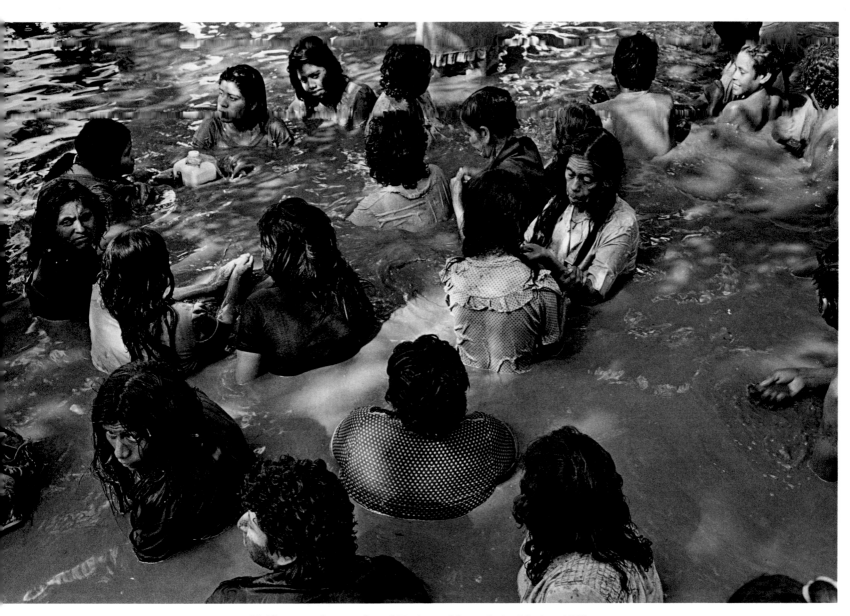

El Chaquito, the sacred pool, Espinazo, Nuevo León, Mexico, 1988

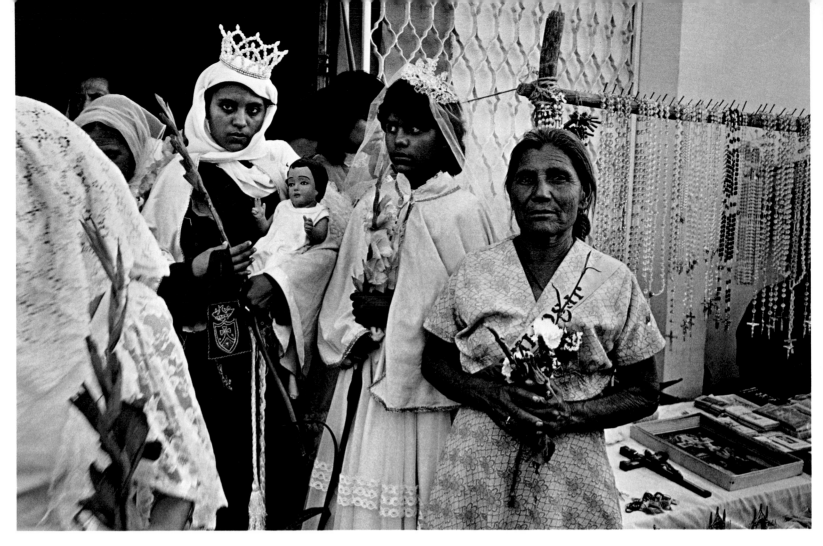

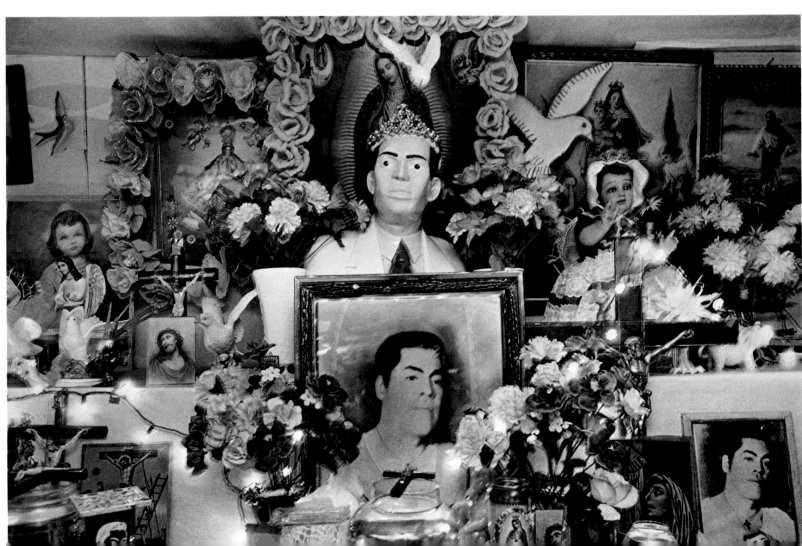

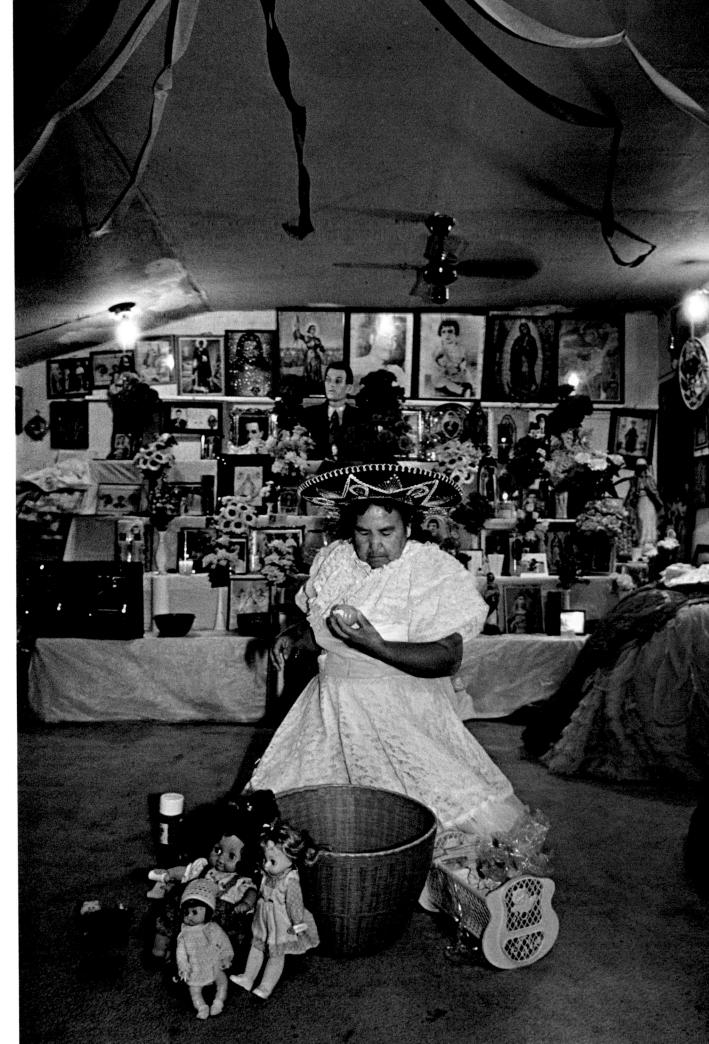

Opposite top:
*Outside
the* tumba,
Espinazo,
Nuevo León,
Mexico, 1988.
Opposite
bottom:
El Tronito
*(Little heaven)
shrine at
Niño Fidencio
Mission,*
Nuevo Laredo,
Mexico, 1986.
Right:
*Aurorita
Weslaco,*
Texas, 1991

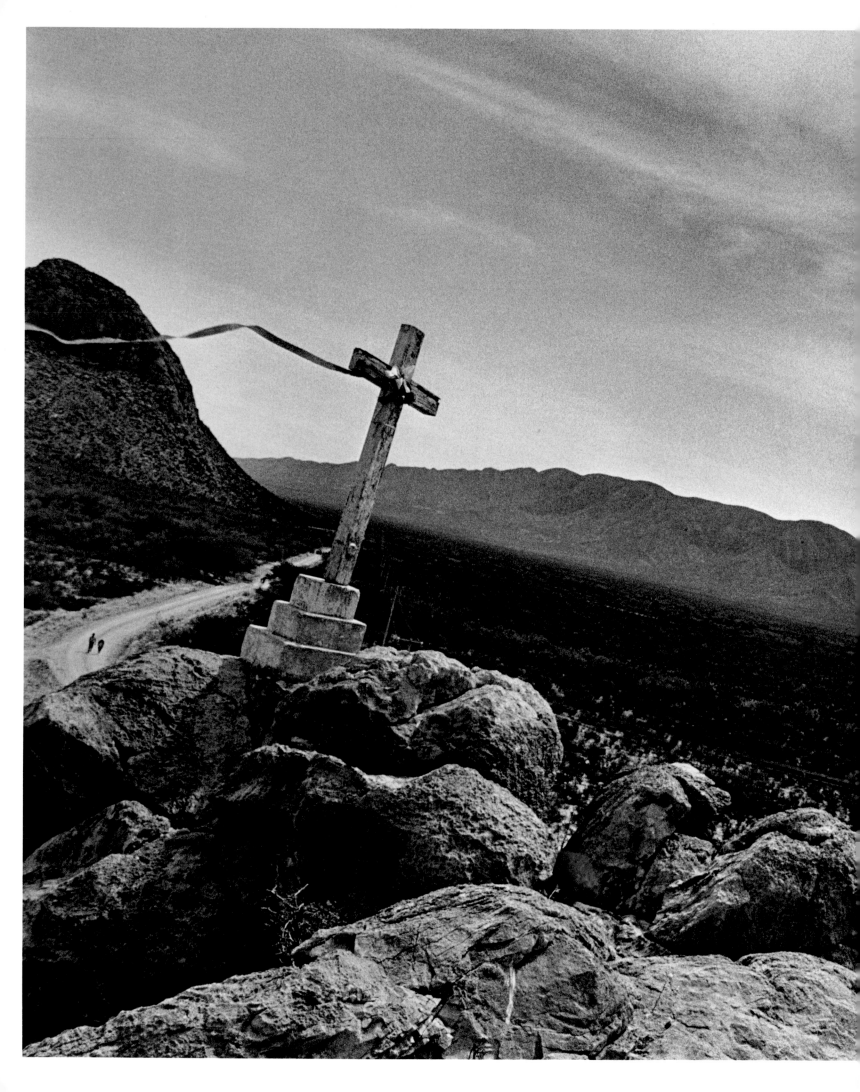

El Cerro de la compaña,
Espinazo, Nuevo León,
Mexico, 1987

PEOPLE AND IDEAS

THE FINAL FRONTIER?

By Richard B. Woodward

On June 2, 1966, the first of NASA's seven lunar probes, Surveyor 1, came to rest north of the crater Flamsteed in Oceanus Procellarum. Equipped with a television camera that featured a zoom lens, a variable iris, and a rotating mirror assembly, the probe obediently looked every which way, including down at its own titanium feet, and relayed images of the forlorn, pitted landscape to the Jet Propulsion Laboratory (JPL) in Pasadena. There, a still

SEGMENT 3

SECTOR 12 SECTOR 11

DAY 021, SURVEY P
SECTORS 11 AND 12

camera photographed the digitized images off a video monitor, capable of either 200- or 600-line resolution. The results were many thousands of bite-sized prints (each about two inches square), which the U.S. Geological Survey in Flagstaff, Arizona stapled to sheets of paper, marked with warped grids and other cartographic coordinates, and worked up into the first true, comprehensive, ground-level study of the moon's varied barrenness.

From such exacting, if pragmatic, origins were born some of the most startling photographs to emerge from the late '60s. Each shimmering moon map, actually a composite of between fifty and one hundred separate frames, has the tessellated structure of a handcrafted mosaic and the mind-numbing objectivity of a scientific survey undertaken in the deepest desert. Assembled to prepare the ground for the manned landing in 1969, the views exploded notions that the surface would not support astronauts, yielding critical information on volcanicity and erosion. They were not the first pictures taken on the moon: the Soviet space probe Luna IX had soft-landed four months earlier and produced a series of panoramic, high-contrast photographs. But the Surveyor probes offered eyewitness accounts from all over the satellite, for about a year and a half, under many seasonal and light conditions; and the range of views sent back could be said to possess as much history and romance now as John Adams Whipple's earliest daguerreotype from 1851 of this "chill and friendless place."

An exhibition last fall of thirty-seven of these maps at the Gagosian Gallery in New York surrounded them with black ash and cool white lighting, a swanky frame that transported them from the cover of *Life* magazine in 1966 to the art world of the

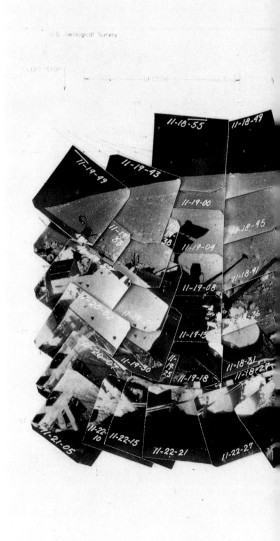

1990s. About three hundred maps, each in a set of three, were completed for NASA. But it seems that they were quickly shelved and forgotten. Donated to the Colorado School of Mining, which unloaded them on the Colorado Science Center, they were picked up a few years ago by a Denver book dealer, who sold a sample to Norman Brosterman, a New York dealer who collects "the future" (science fiction paintings, modernist toys, space suits). A selection from his collection exhibited last spring piqued the interest of photography dealer Daniel Wolf, whose holdings the Gagosian show represented.

The maps seem to shed reflected light on near-simultaneous developments in

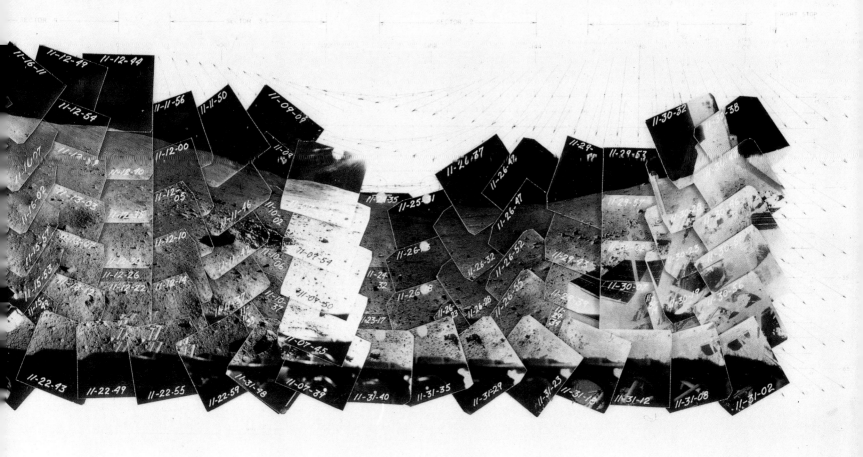

The nimbus of false grandeur that had hung over landscape photography began to dissolve as both artists and scientists scanned the most mundane patches of earth and moon.

Minimalism and Earth art. The prosaic grids and the irregular, humped shapes of the completed pieces bring to mind examples from the work of Robert Smithson, Sol LeWitt, James Turrell, Jan Dibbets, Michael Heizer, Hollis Frampton, Gordon Matta-Clark, and Hamish Fulton. Both

NASA and American artists of the time were documenting their own incursions into and small alterations of undifferentiated terrain. The nimbus of false grandeur that had hung over landscape photography began to dissolve as both artists and scientists scanned the most mundane patches of earth and moon. At the same time these pictures seem to look forward to experiments by David Hockney in real-time, to the somber theatrics and cut-and-tape techniques of Doug and Mike Starn, and to such '80s obsessions as mediated imagery and surveillance. Andy Warhol's frequently expressed wish to be a machine was granted to the geologists of the U.S. space program.

Questions of influence seem less impor-

tant in cases like this, however, than the shared vocabulary and concerns. The lunar landscapes photographed by NASA's robots and the austere impartiality of the Minimalists complement each other. Virtually every map is full of rewarding visual material: scattered rocks across an endless plain, myopic perspectives from inside a crater, self-reflexive views of mechanical body parts, the long shadows cast by the probe as the lunar day draws to a close. Markings at the top of each map record the length of time it took to transmit the images to the JPL, often more than an hour. The circumstances of telemetry from space demanded what was about to preoccupy Hockney: a break with the split-second,

71

monolithic point of view. Changes in printing paper, from matte to glossy, indicate that scientists sought moody effects as well as topographic precision. Their handiwork can look as richly metaphoric and well-crafted as one of Timothy O'Sullivan's western landscapes.

These orphaned images looked peculiar at Gagosian, where they carried an inflated price tag of $10,000 apiece. Speculating on their value may very well taint their bold beauty. They are first and foremost a group of documents from the early space age. However much they may belong in the next museum retrospective on photography, performance, and Minimalist art from the '60s, these are maps of rocks made by geologists, Edenic in their innocence. One did not know whether to be grateful that art dealers have rescued what America's science establishment had so cavalierly thrown away, or to be worried that such a display will grossly distort the nature of their value and intent.

PHOTOGRAPHING THE MIND'S EYE

By Clay Reid

When we see, the first stage is photographic; an image is focused on the back of the eye and light-sensitive molecules are transformed by the projection. After this, the brain takes over. The visual system is perhaps the best-studied part of the brain, but despite over a century of scientific research, the path from eye to brain to awareness is understood only in outline. Recently, this problem is being researched in a novel way: by making images of the brain in action. With several newly developed techniques, it is now possible to take pictures of what was hitherto invisible—the physical signature left behind by a thought.

Accurate pictures of the brain have been around since the work of Andreas Vesalius in the mid sixteenth century. But knowledge of the brain's workings began only in the late nineteenth and early twentieth centuries, when brain activity was discovered to be electrical and chemical. To the unaided eye, the brain looks no different awake or asleep, watching the night sky or listening to a symphony. Most knowledge of the brain was, and still is, based on chemical formulas and graphs of electrical activity, not on actual images. But with recent technological innovations, neuroscientists who study vision have created startling pictures of the mind in action.

From antiquity through the seventeenth century, there were no accurate theories of any aspect of vision. The eyes, whose optical elements are now so evident to us, were a complete mystery. In the 1570s, Giambattista della Porta began the first systematic examination of the camera obscura and optics. Soon thereafter, in 1604, the astronomer Johannes Kepler produced an unprecedented description of the eye as an optical device. Before della Porta and Kepler, vision had no known counterpart in the physical world. After their theories were introduced, people realized that the workings of the eye could be mimicked by a simple trick in a darkened room. Today, cameras are a part of everyday life, and there is less mystery surrounding vision. But with our increasing ability to study the visual brain, we are beginning to catch glimpses of

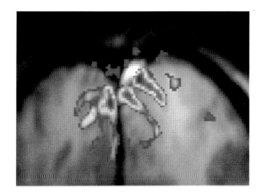

Above: A standard MRI picture of a slice through a living brain. The superimposed color image is a *functional MRI* of the most active portion of the mind's eye.

Right: Optical image of the visual cortex. Regions of the brain receiving input predominantly from the left eye are shown in red. Regions receiving mostly right-eye input are shown in blue. The brighter, yellowish regions, known as "blobs," are important in the brain's processing of color information. The wavy yellow line at the right is a small blood vessel on the surface of the brain.

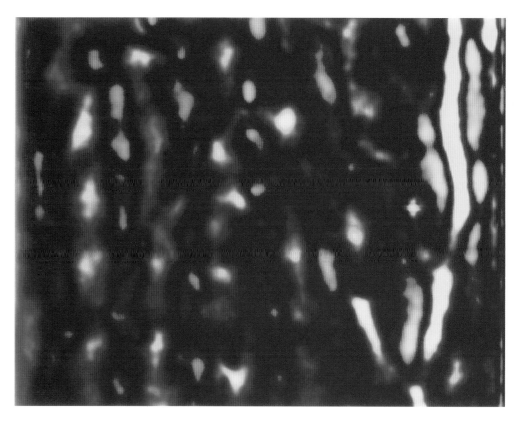

a system of extraordinary complexity.

In the past ten years, a process known as magnetic resonance imaging (MRI) has been used in research and in medicine to produce images of the inside of the body and brain. These images are similar to X rays or CAT scans, but provide greater detail. Originally, MRI was a technique that could inform us about anatomy only: it made pictures of structure, not function. However, with modifications, the same machines can now effectively make maps of brain activity from second to second.

Standard MRI looks through the skull to reveal the convoluted structure of the cerebral cortex, where most "higher" brain functions are performed. With the new technology of *functional* MRI, we can photograph the bulb that lights up in our head when we have a thought. Functional MRI can show us which portions of the brain are performing a given task. For instance, when a subject is seeing, the visual cortex lights up; all visual information that reaches other cortical centers, and ultimately our awareness, is funneled through this region. Interestingly, regions that light up when a person sees also light up when he or she merely thinks of images with closed eyes.

Functional MRI and similar methods are beginning to show us the layout of the

It is now possible to take pictures of what was hitherto invisible— the physical signature left behind by a thought.

centers of visual processing in the human brain. The techniques show brain activity through the skull, but they are limited in resolution. A more directly photographic approach, called optical imaging, has been used both experimentally and in human neurosurgery to create a much more detailed picture of brain activity. Optical imaging uses very sensitive TV cameras, which have shown that the color and reflectance of the brain may change with mental activity. By amplifying these minuscule changes, optical imaging can make highly detailed pictures of the brain in action.

Some of the most striking functional MRI pictures show the visual cortex within the human brain, and optical imaging also has found one of its first real successes in the study of the visual cortex. At the scale of optical imaging, the visual cortex has an ordered, repetitive structure, first described by the pioneering studies of David Hubel and Torsten Wiesel in the 1960s. The sig-

nals from the two eyes are kept separate in the visual system until they can reach the cortex. At this point, they are interdigitated across the cortical surface to form strips known as ocular-dominance columns. If the eyes are a stereo camera, the visual cortex is the stereopticon where the information is first integrated into 3-D images. This integration is dictated by the overall cortical architecture, which is made up of modules that repeat roughly every millimeter. Optical imaging allows these ocular-dominance columns to be observed for the first time in a living animal.

The modern conception of the eye as camera is a useful metaphor, but it has helped to obscure the complexity of the visual brain. In the early days of artificial intelligence, scientists in the field predicted that machines would "see" within a short period of time. Thirty years later, many of the simplest visual tasks are still difficult or impossible for even the most advanced computers. One thing is clear: our visual faculties are at least as complex as what we consider the more "intellectual" functions of our brain, such as language. With the new MRI and optical imaging technologies, we are able to train our most sophisticated sense upon itself: to make use of images to study how we process visual information.

THE DIGITAL TRUTH

By Michael Sand

William J. Mitchell, *The Reconfigured Eye: Visual Truth in the Post-Photographic Era*, The MIT Press, Cambridge, Massachusetts, 1992. ($39.95).

Are you prepared to take a ride into the "post-photographic" era? William Mitchell is prepared to take you there. And although old-fashioned chemical-and-film photography gets plenty of play in the early pages of *The Reconfigured Eye: Visual Truth in the Post-Photographic Era*, when the medium is declared dead by page nineteen it's clear we had better buckle up quick:

> From the moment of its sesquicentennial in 1989 photography was dead—or, more precisely, radically and permanently displaced as was painting one hundred and fifty years before.

Mitchell begins with the usual history of the invention of photography, presented in staggeringly terse form: it takes him all of page one to get from Fox Talbot to the first computer digitization of images in the 1950s. And he's still just revving his engine.

The book, one of many slickly designed recent offerings from The MIT Press, is a fine example of an odd hybrid form: the textbook/coffee-table book. No doubt the publishers are hoping to attract two audiences, the academic as well as the layman with an interest in the field. And they may well succeed. *The Reconfigured Eye* is instructive without being overly pedantic, and succinctly if not always gracefully written. It is also replete with color and black-and-white images from all over—everything from Velásquez's *Las Meniñas* to Diet Coke commercial stills.

If there is an underlying theme to *The Reconfigured Eye* it is the instability and ubiquity of the image in contemporary society. This is not really the Information Age, the author seems to suggest, as much as it is the Age of the Mutable Image. Many people (and photojournalists in particular), seem threatened by the specter of this new era: how will we control the image-in-transition, a mere cluster of pixels on a screen that could take solid form on a page at any stage in its amoebic life? Who will ensure that the image processors will not pull a slew of fast ones on us, subtly altering our "news" photographs in ways that could influence the course of history? How will we know?

At times Mitchell himself seems perplexed by such questions, but a giddy enthusiasm keeps the discussion bobbing atop an ocean of uncertainty: "visual truth" may indeed be endangered now that we can alter images quickly and seamlessly, but all the more reason to become aggressive handlers of digital information. We're witnessing evolutionary theory applied to the New Photography. Manipulate or be manipulated is the implicit message.

Drawn from the author's seminars at the Harvard Graduate School of Design, *The Reconfigured Eye* has the confident pacing of a well-rehearsed lecture series. Mitchell, whose background is in architecture, has spoken and written about related material on many occasions (including in a book on computer-aided architectural design and another on computer-graphics programming), and his proficiency with the language of imaging is impressive.

The examples Mitchell cites to back up his arguments are well chosen for their clarity, their directness, their pragmatism. He is like a frustratingly knowledgeable professor, who happens to be launching into unfamiliar territory with frightening alacrity. From time to time, Mitchell lapses into white-smocked laboratory talk, which may be off-putting to some readers, but he is also capable of producing the odd gem, as in a passage on Gulf War imagery, which concludes, "Slaughter became a video game: death imitated art." The combination of a faint literary bent and a firm grasp on scientific jargon occasionally gives rise to inexcusable utterances, as in Mitchell's invocation of a techno-muse at the end of Chapter 4: "Mnemosyne has become a digital matrix."

At least half of the book is given over to

How will we control the image-in-transition, a mere cluster of pixels on a screen that could take solid form on a page at any stage in its amoebic life?

Perspective and color theories from the Renaissance are brought up to date with "ray tracing."

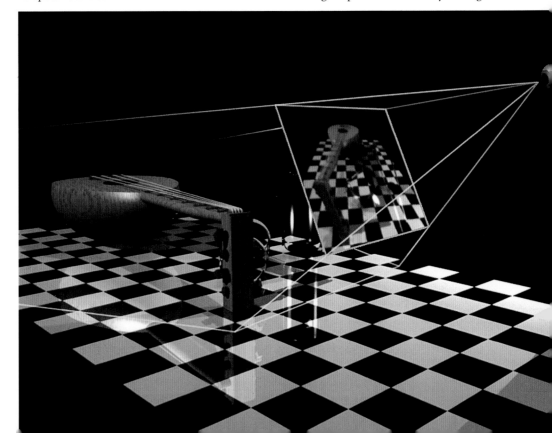

a detailed analysis of the process of digital imaging, with sections devoted to filters, colorization, sharpening and smoothing, light sources, various kinds of shading, shadows, transparency, "false foreshortening," and the like. More often than not, Mitchell relies on conventional art-historical terminology to describe what it is that happens on-screen to images that may have begun as photographs, paintings, mathematical formulas, or some combination of all of these, and now are reduced to a thousand points of light. Drawing and perspective strategies dating from the Renaissance are resurrected with new salience for the computer artist. While it is not truly an instruction manual, *The Reconfigured Eye* does provide the basis for a thorough understanding of the various available techniques and is must reading for anyone who would pick up a digital "paintbrush" to tamper with a photographic image.

We have grown accustomed to the digitization of the word, and word-processors have altered the way people write in much the way digital-imaging systems are bound to alter the way we create and utilize images. The ease with which writers can add and delete sentences, move text from one section of a file to another, even change the size and shape of the letters on screen, is paralleled in imaging: it is now possible to edit as you "write" a photograph onto the monitor. Images, like words, can be sent via telephone lines from one place to another, from a World Series game or the scene of the crime to the newsroom in a matter of minutes. Once on-screen, they can be altered instantly to meet the demands and attitudes of the day.

Just how these advances will be implemented and "visual truth" not trampled in the process is left unclear. Mitchell, like many others who have written on the topic, does not fully address the issue of accountability in the Age of the Mutable Image. But that's not really what he has set out to do. Rather, he invites a drastic reassessment of what we can rightly expect from the photographs that are put before us, by unveiling the manifold ways that they may have been invented. In quest of the quotable phrase, Mitchell is undeniably too quick to pronounce the death of the medium as we know it. Photography is not dead, it is merely twitching with inordinate growing pains.

ANCIENT RUINS, MODERN TIMES

By David LaPalombara

Campagna Romana: The Countryside of Ancient Rome, photographs by Joel Sternfeld, with essays by Richard Brilliant and Theodore E. Stebbins, Jr. Published by Alfred A. Knopf, New York, 1992 ($60.00).

The Roman countryside embraces a robust juxtaposition of historical structures, cultural artifacts, and contemporary construction. Its undulating lowlands bear witness to those who lived and died there, and to those who are developing the land today. The remains of Roman aqueducts, Medieval towers, abandoned farmhouses, villas, tombs, and other signs of earlier habitation abound, and all find their way into Joel Sternfeld's book *Campagna Romana: The Countryside of Ancient Rome.*

Within the walls of old Rome are a panoply of ancient ruins with examples of Renaissance, Baroque, nineteenth-century, and modern architecture. In many neighborhoods, like the Campo dei Fiori, the collage of building styles and periods can be startling and sometimes beautiful. What differentiates the abutment of old and new in the Roman countryside from that in other urban areas, however, is the abrupt and frequently harsh contrast between the elegant brickwork and majestic scale of ancient structures and the trademark steel-and-concrete featurelessness of post–World War II architecture.

Artists have long depicted the Roman countryside and its ruins as both the background and the subject of their work. Inspired by remnants of ancient culture and civilization, Claude Lorrain, Nicolas Poussin, Jean-Baptiste-Camille Corot, J. M. W. Turner, Thomas Cole, and others all ventured into this landscape to paint at one time or another. And as Theodore E. Stebbins notes in his introduction, Sternfeld was by no means the first photographer to document the ancient ruins in the Roman countryside. Where Sternfeld differs from most of his predecessors is in the presentation of this material. Instead of romanticizing the majestic ruins and glorifying an

ancient time, he offers a somewhat critical view that communicates the urgent need to preserve this landscape and its splendor. One of the book's fold-out triptychs depicts a VW/Audi billboard advertising a car driving through a field of flowers, with the words "Lavoriamo per la pace tra l'automobile e la natura" (We are working for peace between cars and nature) written below. Behind this equivocal claim, to add to the irony, sit a corrugated steel retaining

The fact that tourists pass through the lowland areas on their way to or from other places bodes poorly for the future of this region.

wall, a construction crane, and a partially carved-away hill.

Stebbins suggests that the inhabitants of the Roman countryside are ignorant and unappreciative of the history and context of the ancient remains that surround them. Most of Sternfeld's photographs support this interpretation: lovers seek privacy by parking beneath the remains of a gigantic, pyramidal tomb from the second century A.D.; a pair of joggers is oblivious to the remains of the Claudian Aqueduct behind them; and a group of people in the Gordiani Park go about their business, apparently unaware of the towering remains of the nearby Grand Nyphaeum baths.

In the midst of so many photographs depicting the neglect of the land Sternfeld does hint, however, that some Italians comprehend the losses that are being caused by redevelopment. A nun picking flowers in the dump behind the convent, next to the dilapidated apartment building, appears genuinely sorrowful. In another photograph, a group of Italian women assemble for their "daily gathering" alongside the scanty remains of a Roman wall in a neighborhood park, as if to defy the rows of nondescript, concrete apartment buildings

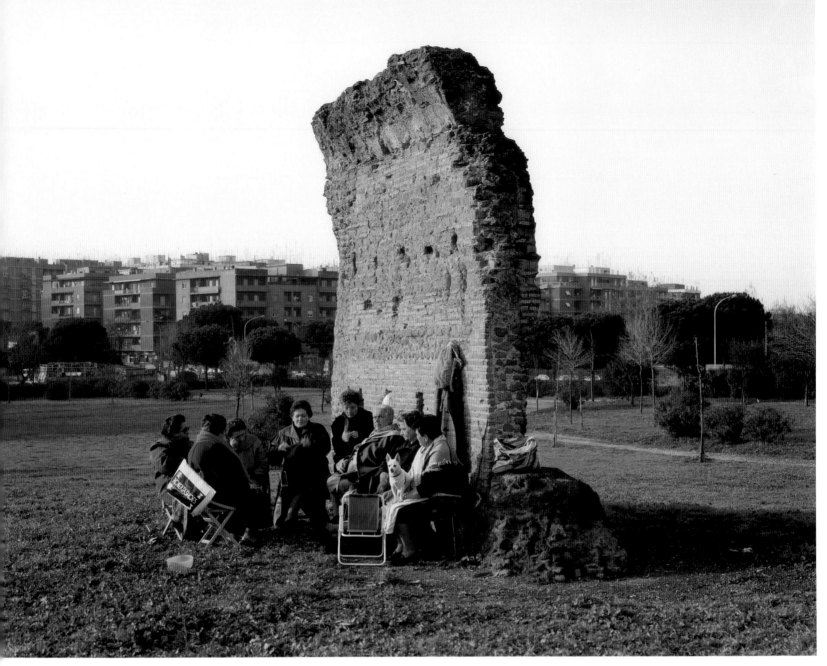

Women at Their Daily Gathering Beside an Ancient Roman Wall, Parco dei Gordiani, Rome, October 1990

in the background. The ancient wall is beautiful: it reflects a warm light and the brickwork creates a fascinating pattern. Embodied in the decaying handmade stone construction is the sense of enduring human spirit.

Some of Sternfeld's pictures are cryptic ironies, others are eloquent testimonies. They celebrate the landscape and warn of its fragility, depicting the uncaring intrusions of modern life. Sternfeld involves people, or evidence of them, in most of these landscape settings. His *American Prospects*, published in 1987, explores similar narrative themes in the United States, but in a more lighthearted vein. (One shot is of a family who stopped to watch the Glen

Canyon Dam in Page, Arizona, for such a long time that they deposited their baby in a portable playpen alongside the car.)

Campagna Romana explores an equally compelling landscape, but with a very different point of view. The Roman countryside and its ruins are deteriorating because of continued redevelopment with no eye toward preservation, and Sternfeld's pictures make this abundantly clear. The fact that tourists pass through the lowland areas on their way to or from other places—the beautiful hill towns, the airport, the Eternal City, or points beyond—bodes poorly for the future of this region.

Sternfeld received a fellowship in historic preservation from the American Academy

in Rome to complete this project. The publisher of the book, Alfred A. Knopf, encourages its audience to support legislation to protect the Roman countryside by making it an archaeological park. Sternfeld's book contains neither pretty snapshots of common, banal sights nor simple, environmental picture-slogans. His exquisitely crafted photographs deserve much praise aesthetically; they also inspire contemplation. Those people who take the time to consider both the artistic merits and the social implications of these images might gain a greater understanding and appreciation of the Roman countryside, and a willingness to take measures to protect its ancient ruins.

BRETT WESTON, 1911-1993

As Brett Weston lay dying in a hospital room in Hawaii, a friend brought in a lush green plant. Brett looked at it appreciatively, and said to his brother Neil: "Get my camera."

Shortly afterwards, on January 22, Brett died. And so ended a glorious, exuberant life dedicated for more than six decades to the perfectly envisioned photographic image.

Brett, like his prints, was an uncompromising and uncompromised original from start to finish.

He was born December 16, 1911, in Carmel, the second of Edward and Flora Weston's four sons. Edward had the gift of recognizing and appreciating the individuality of his children. In Brett's case, this meant coping with a vital, gifted, and almost terrifyingly independent and obstinate boy. Fearing that encounters with authority, including schoolteachers and principals, would land Brett in trouble, Edward took him to Mexico for an extended stay in 1925. At the age of thirteen Brett's formal education ended.

That was the year he began photographing—using Edward's cameras and learning his darkroom techniques. There were also the beginnings of those curiously osmotic relationships that exist among artists. Brett's early adolescence was spent in the company of such luminaries as José Orozco, Diego Rivera, and Edward's mistress, Tina Modotti, among others. Friendships would follow with many of this century's greatest photographers, painters, poets, actors, and musicians. None, however, could be described as an "influence." As an artist, Brett was born the master of his destiny.

"I was electrified the first time I saw the image on the ground glass," he once recalled. It was an emotional power that continued unabated throughout a long, single-minded, and productive career. In fact, Brett seems to have completed himself in most respects by the time he was eighteen. He had by then discovered his lifelong passions—photography, women, and cars. And in that year he also laid the foundation of his international reputation, with twenty prints exhibited at the Film und Foto show in Stuttgart, one of the great moments of Germany's short-lived Weimar Republic.

Writer Nancy Newhall's critical appraisal of Brett's early photography holds true for his entire working life. "Abstract form dominates," she wrote. "Already his love of intense blacks and whites is evident—black as space in which forms move, black as active force or repeating rhythm; white as pure continuous line, an accent—like a chisel cut or frost on darkness. Equally strong is his feeling for dynamics. Force and rhythm are as important to him as form."

The subject matter ranged from landscapes, industrial machinery, and nudes to microscopic studies of paint rubbings, grease spots, broken windows, and beach detritus. In these latter images Brett discovered arrangements of line and mass that gave his photography a visual life previously achieved only by the finest painters, such as Picasso, Klee, Miró, and especially Braque. He was a traveling photographer. "The impact of a new place can't be described," he once said. "It's a way to refresh the eye." His photographic journeys took him throughout North America, several times to Europe, twice to Japan, and repeatedly to Hawaii.

There was an extraordinary consistency in his work—photographs from his teens are as clearly identifiable as Brett Weston imagery as those taken in his eighties. Yet there was a continual refinement, an emotional and spiritual deepening of his vision.

With an utter lack of mercantile interest, Brett lived simply on a few hundred dollars a month for most of his life. In the 1970s, however, he suddenly found his work greatly in demand and his income soared, allowing the purchase of a top-of-the-line Porsche and the building of a second home in Hawaii. Otherwise, little changed. From midnight to dawn he printed in his darkroom, then slept until noon, and often went back to work. Admittedly ruthless about protecting time for his photography, Brett also loved being with people. He was a belly laugher who delighted in ribald tales and wide-ranging conversation—provided that it was not about photography. He hated "talking shop."

As both a man and an artist, Brett had a rare and, at times, maddening quality: he always expressed exactly what he meant, without nuance, condition, or qualification. A prime example was his approach to printing. Brett was adamant that no one but the photographer should print his own work. He had stated for years that he would burn all of his negatives on his eightieth birthday (his will decreed their destruction in the event of an earlier death). And on his eightieth birthday, with family and friends gathered around—and to the horror of many in the art world—Brett consigned to the flames of his Carmel fireplace thousands of negatives from a lifetime of photography. Then he went back to work, achieving some of his greatest images in the last two years of his life.

The death of such a man leaves an empty place in the world, and we at Aperture mourn with Brett's daughter, Erica, his family, and his many friends. Brett was closely involved with Aperture from the beginning and contributed to our recent 40th Anniversary Issue. He then made another, uniquely Brett contribution. Working with Anthony Montoya, Director of the Paul Strand Archive, Brett provided Aperture with 330 individual prints—spanning a period from the 1950s almost up to his death—which will accompany the limited edition of the revised and expanded *Voyage of the Eye*, our first of two monographs on the artist. It was a gesture typical of Brett's ever-present generosity and friendship.

With the death of Brett Weston, one of photography's purest flames is now extinguished; in his images, the light endures.

CONTRIBUTORS

DORE GARDNER is a Boston-based photographer who has photographed healers, prophetesses, Elvis impersonators, and the old Jewish community in South Beach, Miami. The Museum of New Mexico Press published her book *Niño Fidencio: A Heart Thrown Open* in the fall of 1992.

TEUN HOCKS lives and works in the Netherlands. He designs, builds, and paints the sets for all his photographs, in which he also appears. Since 1979 he has exhibited his work in more than thirty cities in Europe.

MARY KOCOL, who studied photography at the Rhode Island School of Design, has exhibited extensively in the Massachusetts area. In 1991 her work appeared in the exhibition "Pleasures and Terrors of Domestic Comfort," at New York's Museum of Modern Art.

MICHIKO KON studied at Sokei Art School and at the Tokyo Photographic College in Japan. She has had solo shows in Tokyo, Osaka, and at the Massachussets Institute of Technology List Visual Arts Center in Cambridge, Massachusetts.

DAVID LaPALOMBARA is Associate Professor of Art at Antioch College. In 1982 he received a Rome Prize and a Fulbright Fellowship in Italy. He lived and worked in Rome for more than five years. Currently, he makes and exhibits painted landscape screens.

LU NAN started photographing while working as a darkroom technician at *National Pictorial* magazine in Beijing. In 1989 he began photographing in mental institutions in China. His newest project is on the recent reemergence of Christianity in China.

ANNETTE MESSAGER has been a sculptor, artist, and photographer since the late 1960s. She lives and works in Paris, France, and has had exhibitions in Europe, the United States, and Canada.

CLAY REID is assistant professor in the neurobiology laboratory of Torsten Wiesel, president of The Rockefeller University. The laboratory is dedicated to the study of how the brain processes visual information.

ROCKY SCHENCK, a photographer and filmmaker in Hollywood, California, has written and directed over forty music videos. In 1992 he directed Susan Tyrell's one-woman show, *My Rotten Life, A Bitter Operetta*, in Los Angeles.

THOMAS TULIS lives and works in Chattanooga, Tennessee. Since 1986 his work has been included in many exhibitions in the United States. He was selected for the Best of Photography Annual in 1992.

Photographer ANNE TURYN has master's degrees in fine art and linguistics. She teaches photography at Bard College in Annandale-on-Hudson, New York, and at Pratt Institute in Brooklyn, New York. She is the founder and editor of *Top Stories*, a prose periodical, and the editor of *Top Top Stories*, published by City Lights Books.

CHRISTIAN WALKER studied photography and film at the School of the Museum of Fine Arts in Boston, Massachusetts. He received a National Endowment for the Arts Fellowship in Photography in 1990, and in fall, 1992, he was an artist in residence at the MacDowell Colony in Peterborough, New Hampshire.

RICHARD B. WOODWARD has written about photography for numerous publications, including *The New York Times Magazine*, *Vanity Fair*, *The Independent* (London), *ARTnews*, and *The New Criterion*. He is the author of catalog essays on Irving Penn and Ray Metzker, and has contributed to Lee Friedlander's recent book *Maria*, and to forthcoming books on David Levinthal and William Eggleston for the Smithsonian series "Photographers at Work."

CREDITS

Unless otherwise noted, all photographs are courtesy of, and copyright by, the artists.
Front cover: Photograph by Michiko Kon, *Sunflower and Sardines*, 1990, from the series "Eat," courtesy of Photo Gallery International, Tokyo; pp.2–3 top row from left: Christian Walker, from the series "Another Country," 1990, courtesy of Jackson Fine Art, Atlanta; Michiko Kon, *Peach, Lily, and Violin*, 1990, from the series "Eat," courtesy of Photo Gallery International, Tokyo; Thomas Tulis, *Transmission Tower with House*, 1989; middle row from left: Anne Turyn, *Untitled*, from the series "Illustrated Memories," 1983 to present; Dore Gardner, *Death Foto Niño Fidencio*, Espinazo, Nuevo León, Mexico, 1988; Annette Messager, from the series "*Mes Voeux*" (My vows), 1990, dress, black-and-white photographs, string, and safety pins in a vitrine, 51 x 12 x 3", courtesy of Galerie Crousel-Robelin Bama, Paris; Mary Kocol, *View from the Old Porch*, Somerville, 1991; bottom row from left: Rocky Schenck, *Oilville*, 1989; Lu Nan, *Tienkin*, China, 1989; Teun Hocks, *Untitled*, oil on silver print, 47 1/2 x 78", courtesy of Torch Contemporary Pictures, Amsterdam, and P.P.O.W. Inc., New York; pp.18–25 photographs by Christian Walker, courtesy of Jackson Fine Art, Atlanta; p.32 oil on silver print by Teun Hocks, 49 1/2 x 47"; p.33 oil on silver print by Teun Hocks, 7 1/4 x 53 1/2"; p.34 oil on silver print by Teun Hocks, 47 1/2 x 78"; p.35 oil on silver print by Teun Hocks, 41 3/4 x 52 3/8"; pp.36–37 oil on silver print by Teun Hocks, 15 3/4 x 19 1/2"; all photographs by Teun Hocks courtesy of Torch Contemporary Pictures, Amsterdam, and P.P.O.W. Inc., New York; p.48 acrylic on black-and-white photographs under glass with string by Annette Messager, 100 x 8"; p.49 black-and-white photographs under glass with strings by Annette Messager, 78 x 78"; p.50 (top) dress and black-and-white photograph in a vitrine, by Annette Messager, 12 x 51 x 2"; p.50 (bottom) dress, black-and-white photograph, string and safety pins in a vitrine, 12 x 51 x 3"; p.51 black-and-white photographs under glass with string by Annette Messager. Each photo is 2 x 3", installation is 59 x 10"; pp.52–53 black-and-white photographs, framed, eighty-six elements of various dimensions, average size 12 x 8" by Annette Messager; all photographs by Annette Messager courtesy of Galerie Crousel-Robelin Bama, Paris; pp.54–61 photographs by Michiko Kon, courtesy of Photo Gallery International, Tokyo; pp.70–72 photo-mosaics courtesy of Daniel Wolf, Inc., New York, copy transparencies by Adam Reich; p. 73 (left) MRI photograph by S. Ogawa, D. Tank, R. Menon, J. Ellerman, S. G. Kim, H. Merkle, and K. Ugurbil; research conducted at AT&T Bell Labs in New Jersey and at the University of Minnesota Medical School; p.73 (right) optical image by C. Landisman, C. Reid, and D. Ts'o; Research conducted at the Laboratory of Neurobiology at the Rockefeller University. p.74 computer-generated image by Wade Hokoda, courtesy of The MIT Press; pp. 76–77 photographs by Joel Sternfeld, reproductions courtesy of Pace/MacGill Gallery, New York.

CORRECTION Due to an editing error, Sally Mann's text on page 23 of issue #129 incorrectly read: "Each good-news picture, no matter how hard-earned, allows me only a crumbling foothold on this steepening climb—an ascent whose milestones are fear and doubt." Instead, the sentence should have begun, "Each good new picture..."

SAVE $300 NOW AND AVOID THE "IF ONLY'S."

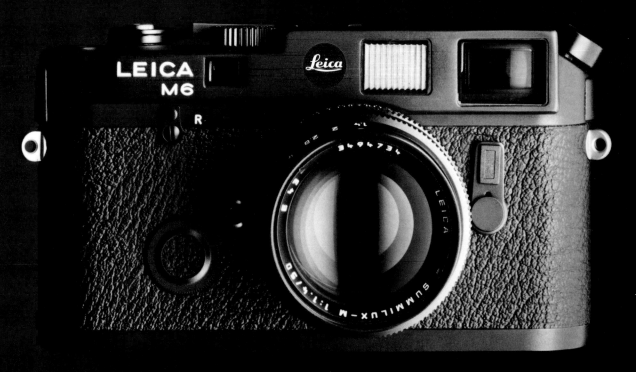

We've all suffered from the "if only's" at one time or another..."if only I'd invested in that stock when it was only fifty cents a share!"..."if only Mom hadn't thrown out my baseball card collection!"... or..."if only I'd bought that M6 I wanted when Leica was offering the $300 trade-in!"

Unfortunately there's nothing we can do about the present condition of your stock portfolio, or your lost fortune in "collectables," but we can give you a chance to save $300 when you trade up to the M6 of your dreams! From September 1, 1992 through January 31, 1993, your authorized Leica Camera Inc. Dealer will give you $300 for your used 35mm camera* (any make, in any condition)

when you purchase a new M6.† And, as part of the deal, he'll also give you $100 for your used 35mm lens toward a new† M-series lens.

The M6 represents an almost unreasonable dedication to quality—meticulous attention to detail, flawless mechanical precision, incredibly quick, quiet handling and optics that defy comparison— an obsession with perfection...and, it will never be easier to afford.

Remember, this is a limited time offer, so what are you waiting for? Call us at 1-800-222-0118 for the names of your nearest authorized Leica Camera Inc. Dealers. Do it today and you won't have to say "if only" tomorrow!

...more than a camera.

Leica Camera Inc., 156 Ludlow Ave., Northvale, NJ 07647 (201) 767-7500
In Canada: Leica Camera Inc., 2900 John Street, Suite 2B, Markham, Ontario L3R 5G3 (416) 940-9262
*Disposable cameras do not qualify for trade-in.
†Only new Leica Camera Inc. products qualify.
Offer valid from September 1, 1992 to January 31, 1993.

Milton Avery Graduate School of the Arts

BARD COLLEGE

ANNANDALE-ON-HUDSON, NEW YORK 12504 (914) 758-7481

MASTER OF FINE ARTS

MUSIC•FILM/VIDEO•WRITING•PHOTOGRAPHY•SCULPTURE•PAINTING

Our unusual interdisciplinary approach to work in the arts has changed the nature of graduate education:

• Direct personal one-to-one conferences with artists in your field are the basic means of instruction—no impersonal classes.

• Response and interaction of students and faculty in all the arts.

• Residence requirements are fulfilled during the summer.

• Our intensive sessions lead in three summers to the degree of Master of Fine Arts.

SUMMER 1993 JUNE 21-AUGUST 13

Faculty: Peggy Ahwesh, Perry Bard, Alan Cote, Lydia Davis, John DiVola, Normandi Ellis, Jean Feinberg, Arthur Gibbons, Regina Granne, Peter Hutton, Ken Irby, Robert Kelly, Ann Lauterbach, Nicholas Maw, Tom McDonough, Tyrone Mitchell, Leslie Scalapino, **Stephen Shore, Anne Turyn,** Stephen Westfall

Recent Participating Artists: Vito Acconci, Mac Adams, Steven Albert, John Ashbery, Zeke Berman, Charles Bernstein, Mel Chin, Maureen Connor, John Corigliano, Petah Coyne, Susan Crile, Larry Fink, Tom Gunning, Gerry Haggerty, Anne Hamilton, Jane Hammond, Ken Jacobs, Tania Leon, Brad Morrow, Tod Papageorge, Lucio Pozzi, Yvonne Rainer, Archie Rand, Steven Reich, Mia Roosen, Judith Ross, Michael Snow, Arthur Sze, Michael Torke, Joan Tower, John Walker